IN AMERICA

A Studio Book

AMERICA

ERNST HAAS

THE VIKING PRESS New York

Library of Congress Cataloging in Publication Data
Haas, Ernst, 1921–
 In America.
 (A Studio Book)
 1. United States—Description and travel—1960 —Views. I. Title.
E169.02.H28 973.92'022'2 75-9597
ISBN 0-670-39463-7

Contents

Acknowledgments

Among those people who have helped me during this book's preparation, I am particularly indebted to the following:

Helen Wright Olga Zaferatos
Bryan Holme Frenchy's Color Lab.
Marina Filicori Time-Life Books
Hope Alexander United Artists Corp.

Introduction

The idea of attempting a photographic essay on America first occurred to me early in the fifties. I had come across a copy of *Winds*, the epic poem written in Maine in 1945 by the French poet St.-John Perse, who later won the Nobel Prize for Literature.

Perse's cantos about America, the continent which has demonstrated to the world in the most extreme way what man can make out of matter and what matter can make out of man, are highly symbolic. No place, face, event, or time is identifiable in the broad sweep of Perse's esoteric poetry. Yet the forceful imagery of his words inspired me to make notes of my favorite passages.

While certain pictures in the present book indirectly reflect the spirit of Perse's poetry, I hasten to say that my attempt to illustrate *Winds* ended almost before it began. In my initial enthusiasm—and that was well over twenty years ago—I had failed to foresee that any photograph placed next to the poetry of an author so fantastically visual with words had to appear either too literal by comparison or too abstract to make sense. To take one of Perse's less ambiguous passages: "The Horsemen on the mesas, trampling underfoot the pottery of dead men and the rose-coloured skeletons of sheep, raise up toward the open sky a burnt soil of powders and bone splinters. . . . An heraldic eagle arises in the wind." Vision after poetic vision lingers in the mind.

Even if it were possible to capture all the imagery contained in a passage like that, the picture could never be in exact accord with the author's words. Poetry can lend wings to thought, but photographs are born from our own experience, our own awareness. From my point of view, pictures begin where words end; they can never successfully follow too predetermined a path.

The frame of the camera is the photographer's discipline. It can contain as much as it withholds, cut into or hold together images that detract or contribute to a given theme. Through it, lines, colors, form, and content all are seen to be related to each other in a very

special way. Every nuance is important in heightening or weakening a composition.

There are both a visual and a literal way of thinking and seeing. Over hundreds of years, the literal has dominated the visual until today our eyes are forced to see in terms of words. My plea is that as far as possible pictures should be allowed to speak their own language. Ancient cave paintings did just that before man devised an alphabet and then, in a symbolic language, started to describe what the eye already understood well enough.

With photography, a new language has been created. For the first time we can express reality through reality. We can look at an impression or an expression for as long as we want, sink into it, and, so to speak, renew past experiences at will.

One day, several years ago, while I was thinking of the present in relation to the past, I remembered how excitedly we used to speak about the American dream. It was then that the point of departure for this book suddenly occurred to me.

I was born in Europe in an era when everyone grew up with a more or less idealistic concept of the New World. America was the last frontier of freedom, the land of peace and plenty, the land of equal opportunity for all. Intermingled with all the lofty slogans and images of utopia were occasional accounts of the bizarre behavior of some of the world's richest people, newspaper and magazine editors making the most of social eccentricities to boost circulations.

It was common, on the one hand, to hear criticism of American materialism; on the other, to find envious romanticizing about the self-made man: the newspaper boy turned millionaire out with a Hollywood goddess in a Cadillac convertible; the ex-office-boy tycoon striding through his castle by the sea on Long Island; or the small-time operator striking it rich with Texas oil.

The New World was a country where dreams could come true. Nations who scorned America were usually those who wanted to copy her, whose laugh could be said to be an anger for what they longed for most.

For well over a century, political, religious, and other pressures sent millions of refugees to the land of promise. Few families remaining in Europe were without at least a friend of a friend who had received letters telling what life in America was really like.

Today things are different. Everyone knows everything. Travel, jumbo-jet fashion, flies millions on package tours around the globe. Television brings New York, San Francisco, Tokyo, London, Paris, even Disneyland into the living room at the flick of a switch, and books carry armchair travelers across continents within a few lines.

My first encounter with Americans en masse was toward the end of World War II. Of all the troops stationed in Vienna, I found the GIs the most relaxed and friendly. Asked about life in Utopia, some laughed in reply, some straightened up with pride, all were delighted to talk about the folks back home and pull out snaps of smiling families or girls.

When marching, how different the GIs were from the noisiest of occupying troops, the Russians. The French were quiet, the English quieter, but the Americans, with soft rubber-soled shoes, were the quietest of all.

I would often ask myself, What were most Americans but people one, two, or more generations removed from European or other immigrant ancestry? What made an American different, what made his country different? In 1950 I crossed the Atlantic to find out.

My first source of wonder was the wealth Americans took for granted—not only the high standard of living, but uncensored books and films, freedom of speech, choice of jobs, and a man's ability to travel anywhere his heart desired without a police permit. All these were unknown luxuries in totalitarian countries.

When I first read the American Constitution, I considered this simple document to be the great hope of the world. I still do. "The most wonderful words ever struck off at a single time by the brain and purpose of man," William Gladstone had said. I couldn't see why it wasn't a law that the words of the Constitution be posted in every public building in the land, to remind us to count our blessings every day.

Most of my preconceived notions about America remained intact. But surprises there naturally were. I hadn't expected such poverty to coexist with such riches, or eye-polluting billboards, signs, and other ugliness to invade the staggering beauties of the countryside to the extent they did, or to find such incredible waste—for which we are now beginning to pay. Everything in America—including hot and cold weather, violence and gentleness—goes in extremes.

From the very beginning I found New York fabulous, not only for its shops, theater, music, museums, but as a city of glass abounding with reflections. They have continued to haunt me ever since in the windows of stores and offices, glancing off the Lever and Seagram buildings, repeated along mirror-like Sixth Avenue (now the Avenue of the Americas)—everywhere. The soul of the city seems to lie in the accumulated art of its reflections. Exciting colorful images race into and out of each other every moment. Never are they, or the city, still.

But New York is not America, and, luckily for me,

assignments for magazine, advertising, and film companies have taken me to all parts of the country. The more I have learned about America, the more fascinating the study of cultural backgrounds has become: the traits of the Puritans, for example. The strict and thrifty precepts of these early New Englanders are reflected in the spare lines of the houses and churches they built; the simplicity that in pioneering days was both a necessity and a virtue became a tradition to be assiduously copied.

In the changing South, I still found the gentility one had been led to expect through old novels and films; restored plantations too, camellia bushes, magnolia and the legendary live oaks under floating shrouds of Spanish moss. In their attributes and manner of speech, Southerners seem to differ from Yankees in much the same way that the imposing red brick houses and broad lawns along the Jamestown River differ from the tight shingle cottages and white captains' houses on Nantucket and Cape Cod, off the waters where the *Mayflower* sailed in.

On the other side of the vast continent I have photographed the plains and mountains, the buffalo and the eagle. In the country of the mesas and adobes I have slept under the stars with the Indians, seen the world from their point of view, talked philosophy in teepees, and felt a strong affinity. And down between the banks of the Colorado River—a geological museum of mammoth proportions—I discovered a pioneering thrill shooting the Lava Falls rapids that had cascaded rebelliously for thousands and thousands of years.

In middle America I stood in awe of the great agricultural wealth of the highly mechanized corn belt that feeds so much of the world, and also admired the friendly people who grew the tall wheat and the corn and displayed such down-to-earth horse sense, simple hospitality, and good humor.

First thoughts of America so often focus on money, big business, oil, expansion, bulldozers, and developers; words that in turn conjure up visions of tall shining cities, factories, billboards, gas stations, and shifting landscapes. Yet also coexisting with all this, and

in silent contrast to it, is the deep country, the faraway acres of forest land still untrodden by man and the rural America of rolling farmlands and villages distant from cities and as yet unspoiled.

Until a few years ago, along some of Maine's byways, farmers yoked oxen to work their land. Perhaps some still do. In parts of Pennsylvania and Michigan the Amish still keep to their little black wagons and strict religious precepts as they have done through the centuries. Paradoxically, simple life styles like these exemplify the direction in which America's new generation seeks to go.

I always wished it were possible to go back in history and photograph the past. Who hasn't wondered what he would see and feel were he to awake a hundred or two hundred years ago? At least I had a chance to experience the next best thing.

Film assignments have often taken me out West on location to places where the past has been reconstructed with ultimate care and attention to detail. The filming of many stories calls for extras who are not

actors but local folk dressed as their ancestors were a century or more ago—camping outdoors, thinking, living, and instinctively acting out the past as if it were the present, as if time had not changed a thing.

It is these things and many others that are reflected on the following pages: mounted Indians charging across the prairie, cowboys, covered wagons, a Fife and Drum Festival, New England at the height of autumn color, the Mardi Gras, a football game on television, a regatta under the backdrop of Mount Rainier, a ride in a Model T. The places, situations, even faces, clothes, and attitudes are so distinctly American in spirit that they could not have been photographed in any other country. Much is American history lived in the present, all is what I like to call living Americana.

Not ten, twenty, or even a hundred times the number of pages could tell the whole story of this vast continent, its history, people, and its spirit, nor contain the number of photographs I have taken. Stories never end because each dawn brings another thought, another picture; each day writes another page of history.

After so many years of thinking visually about America, the publication of this book now coincides with the two-hundredth anniversary of the country. Although this has happened entirely by chance, I like to think the coincidence a good omen.

In dedicating this volume to America, I end here as I do in the last picture with the word "Love" written high in the sky where we all look when we think and dream of the future.

The Plates

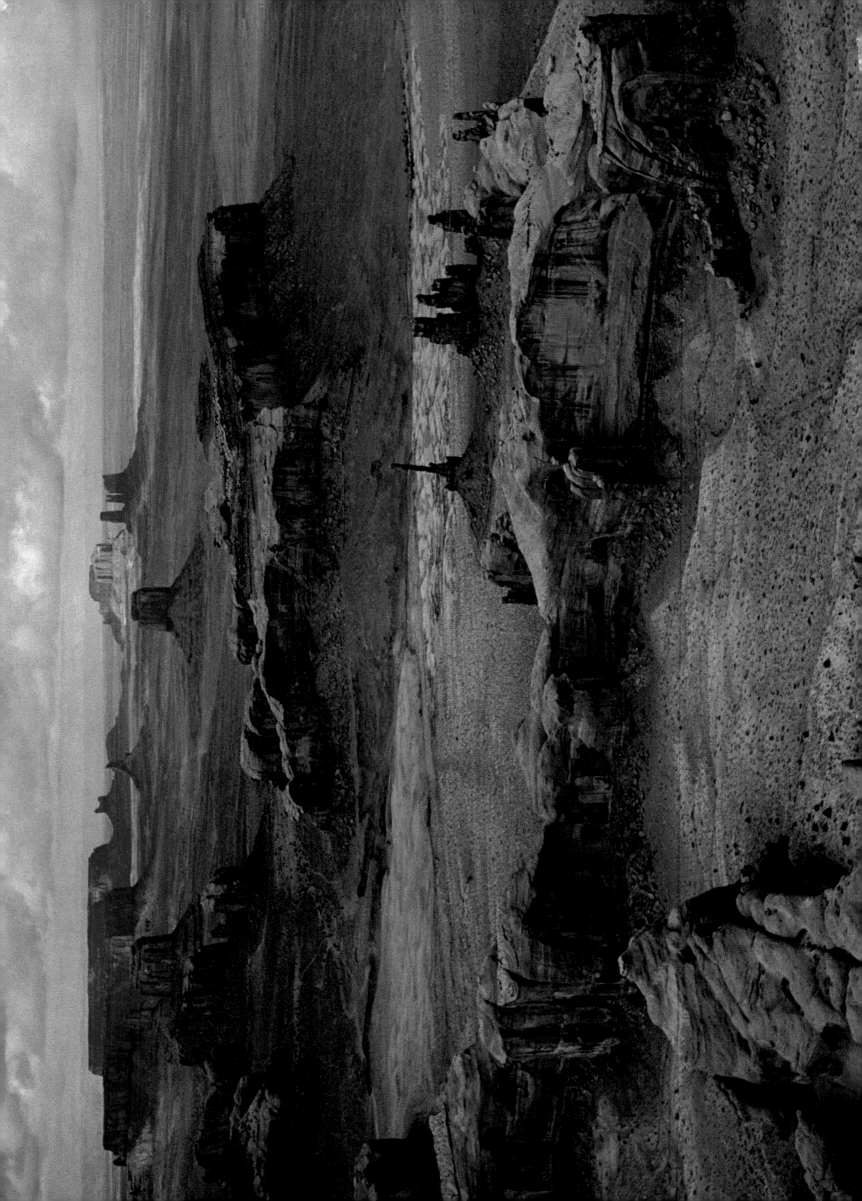

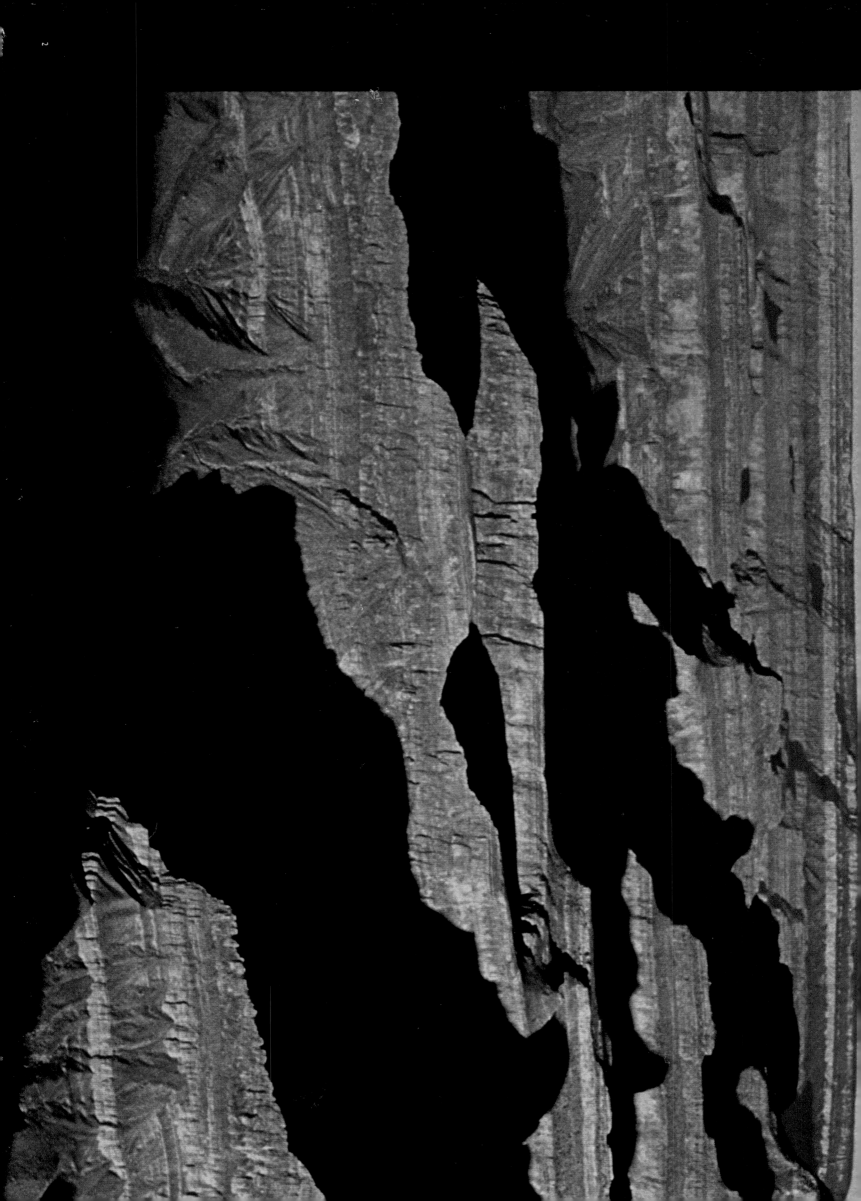

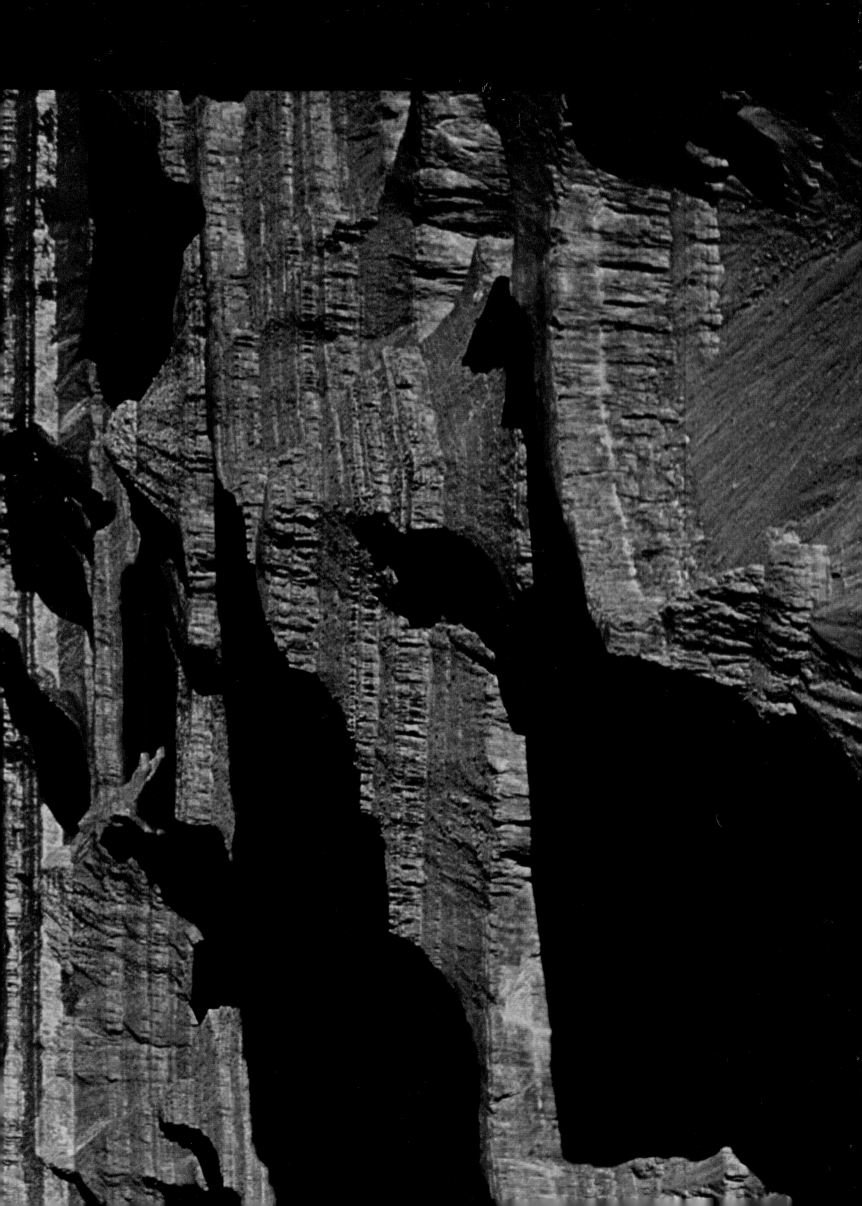

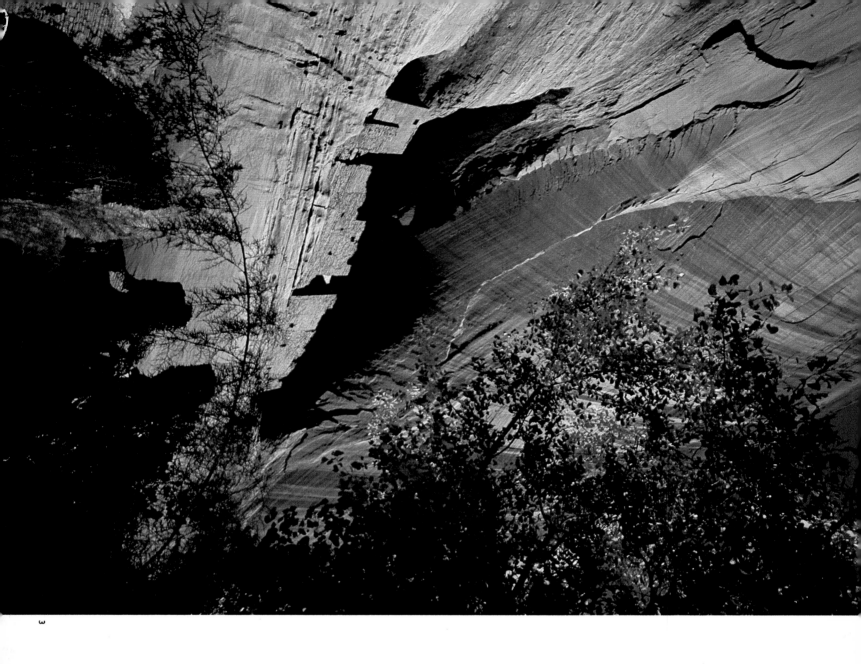

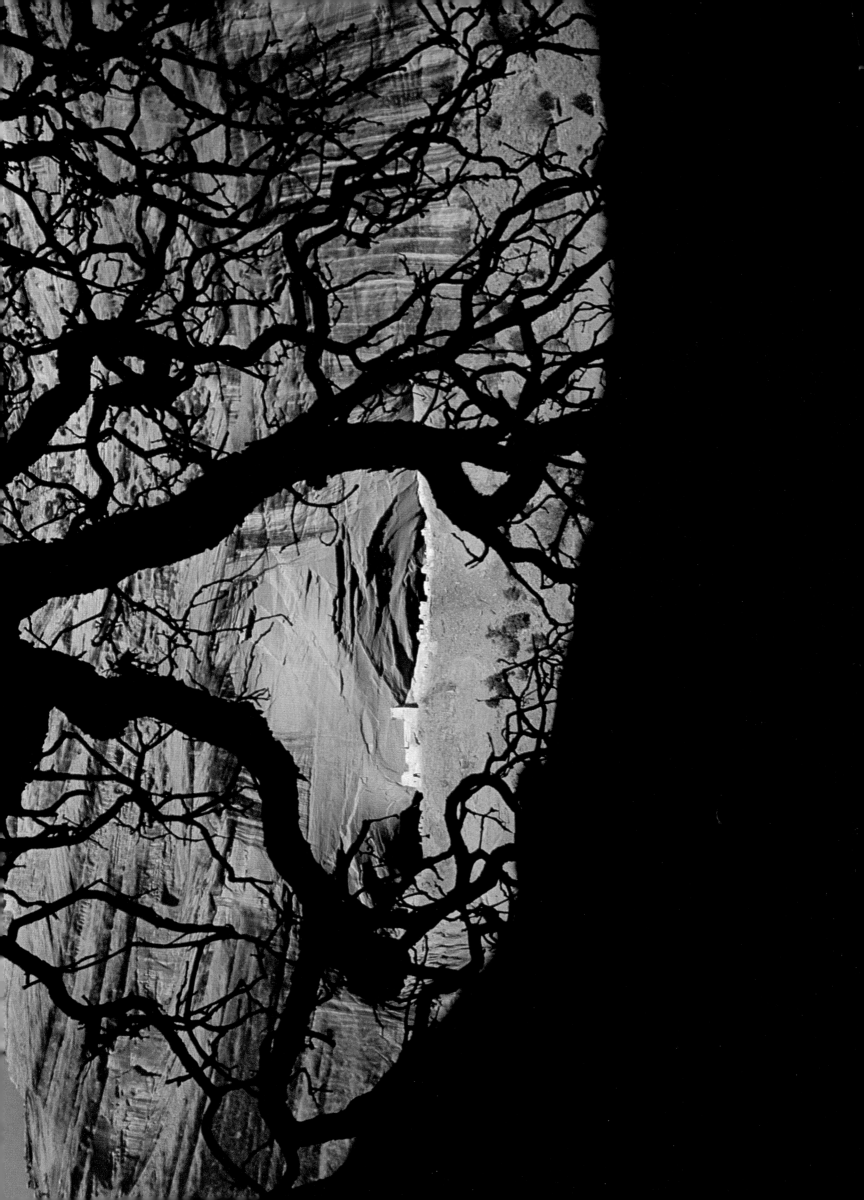

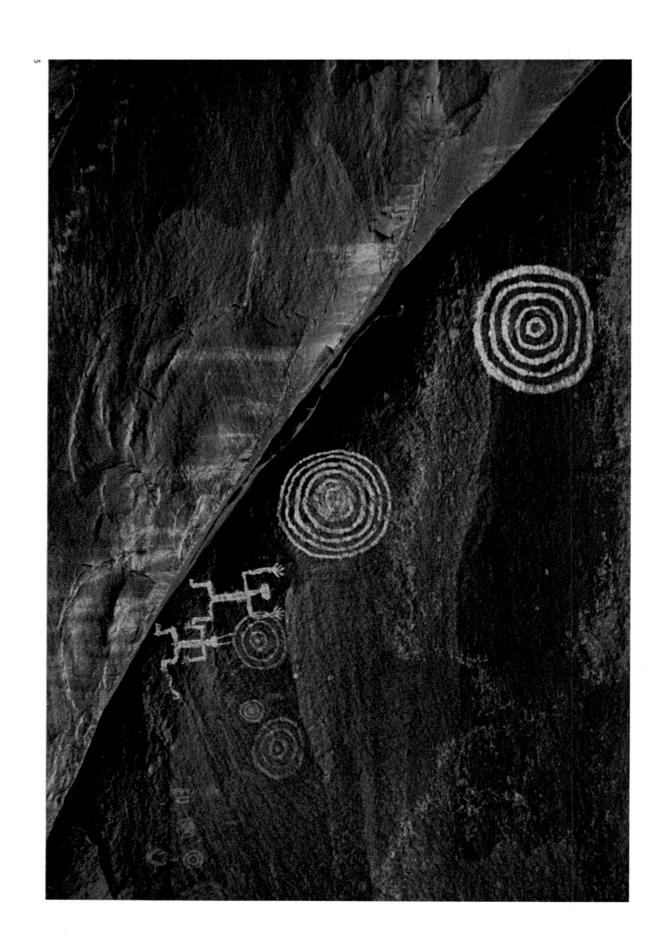

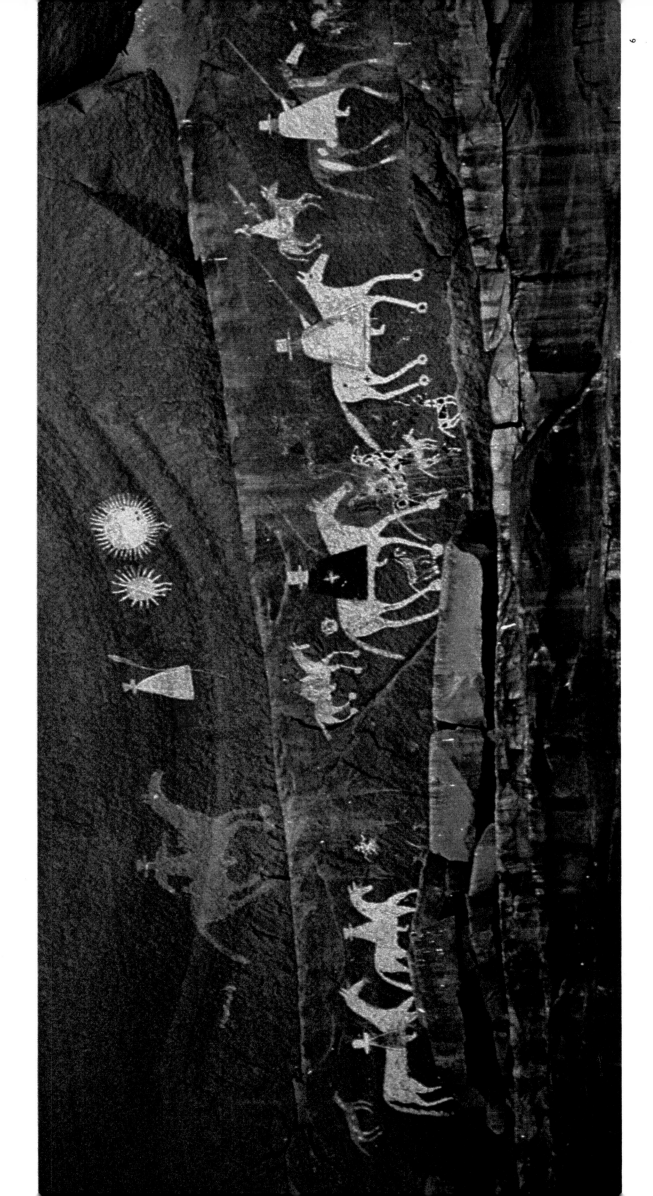

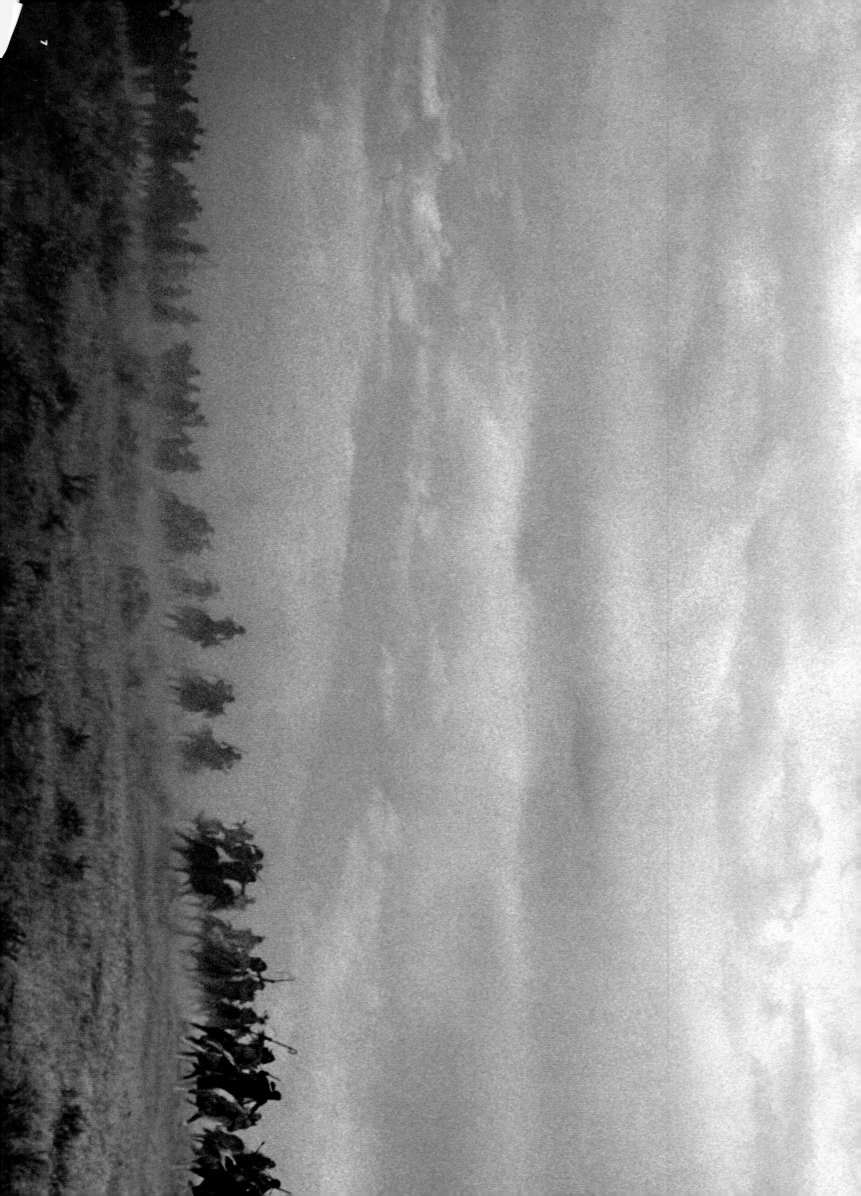

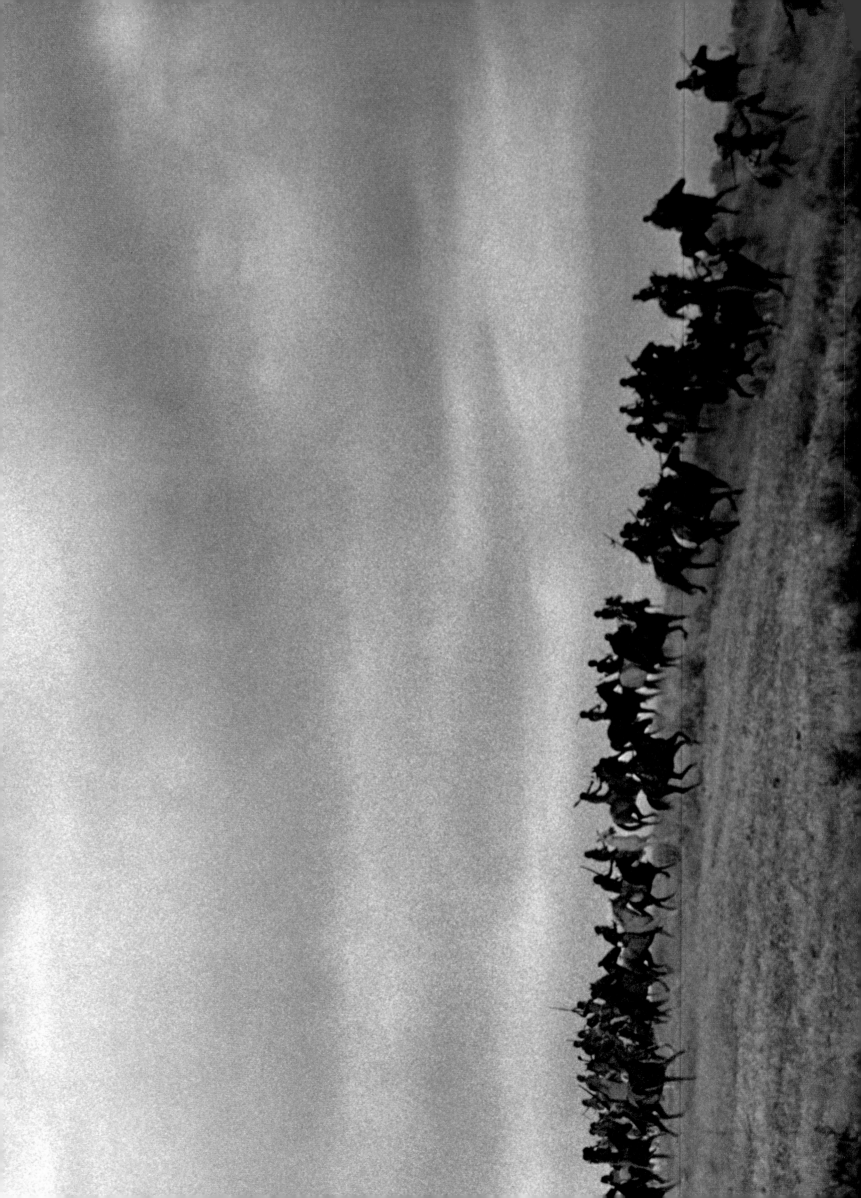

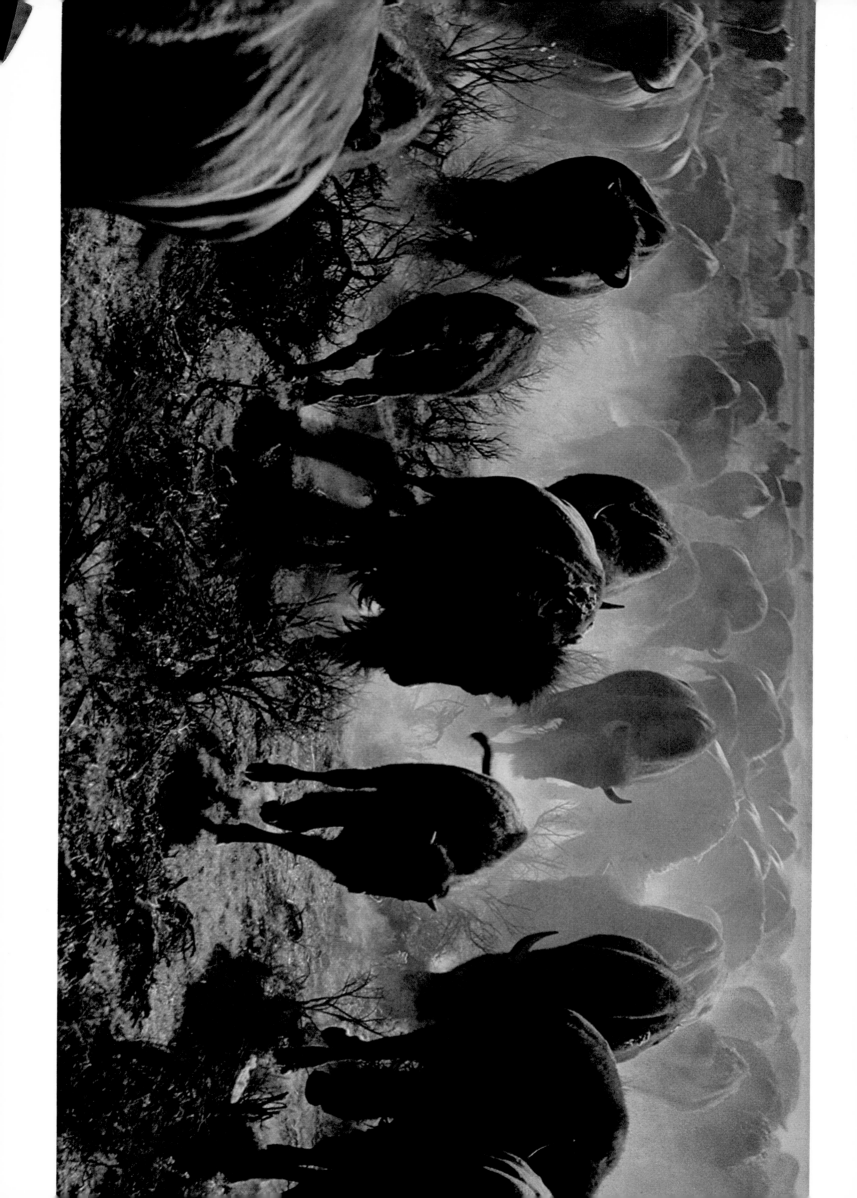

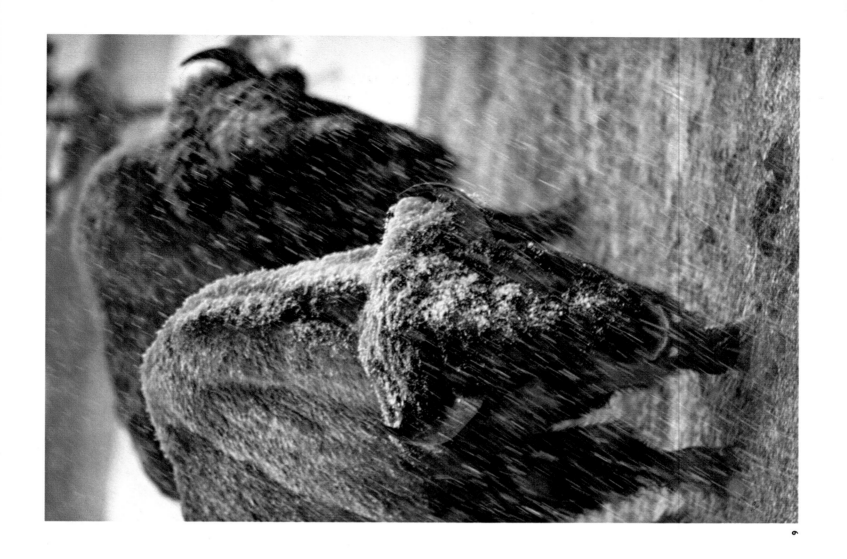

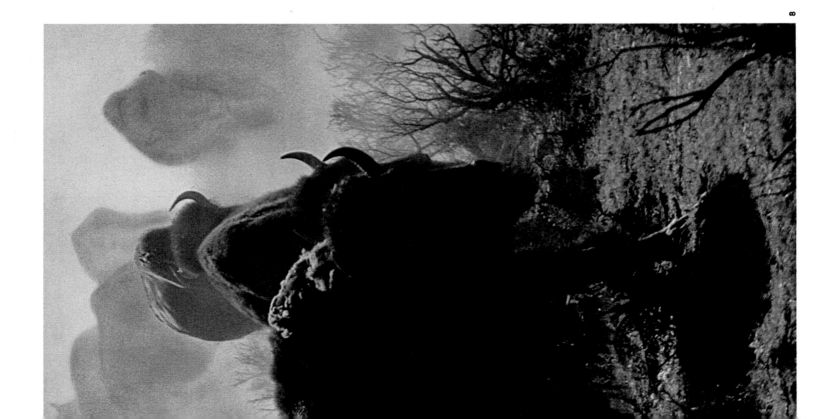

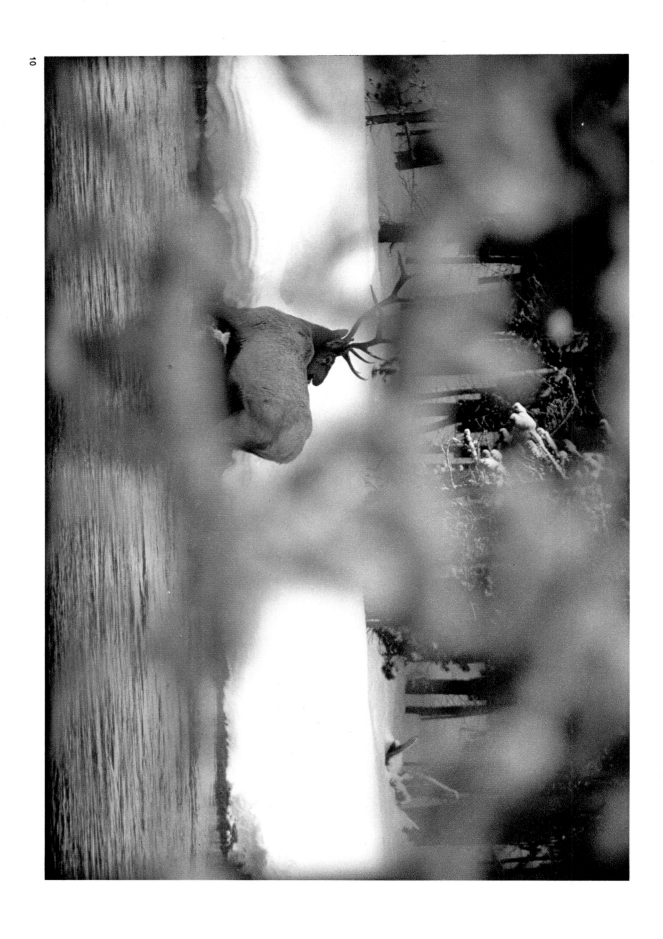

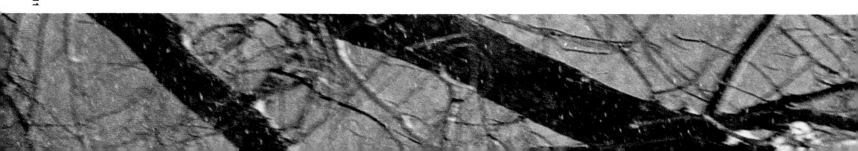

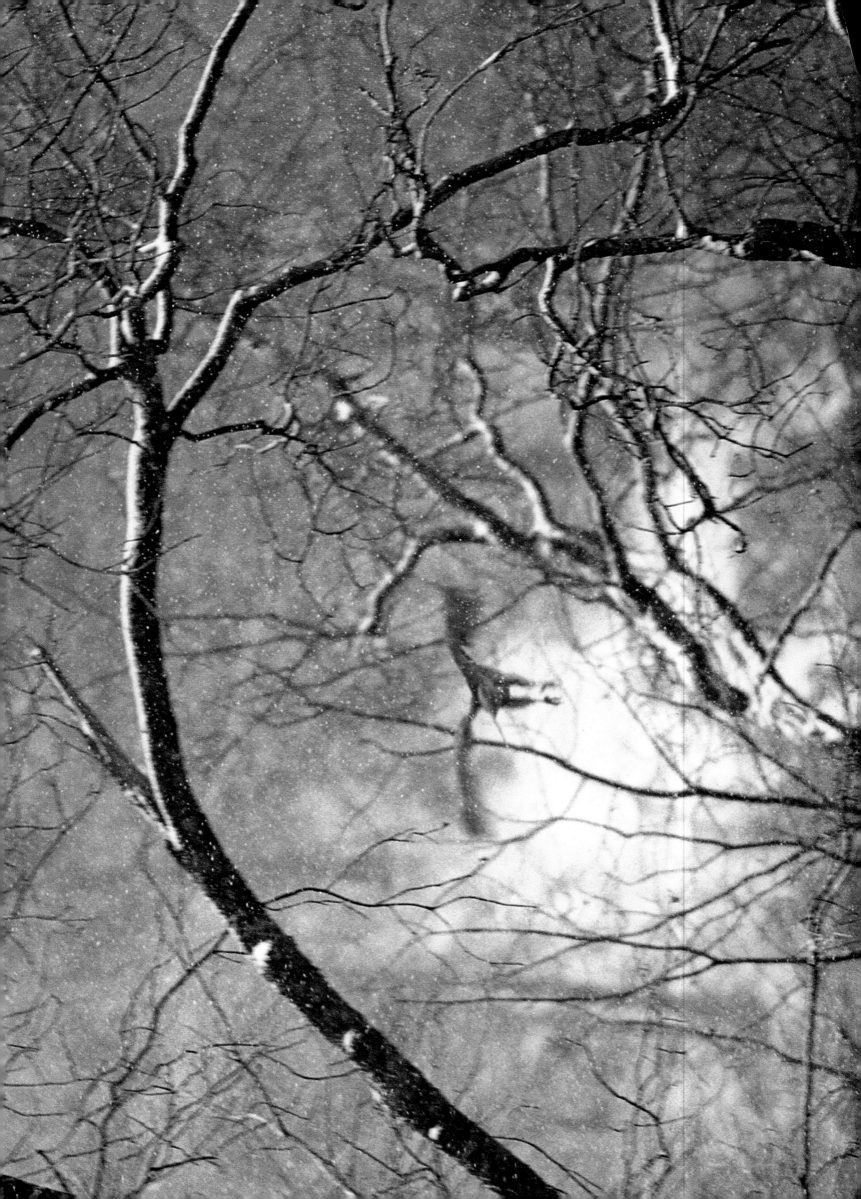

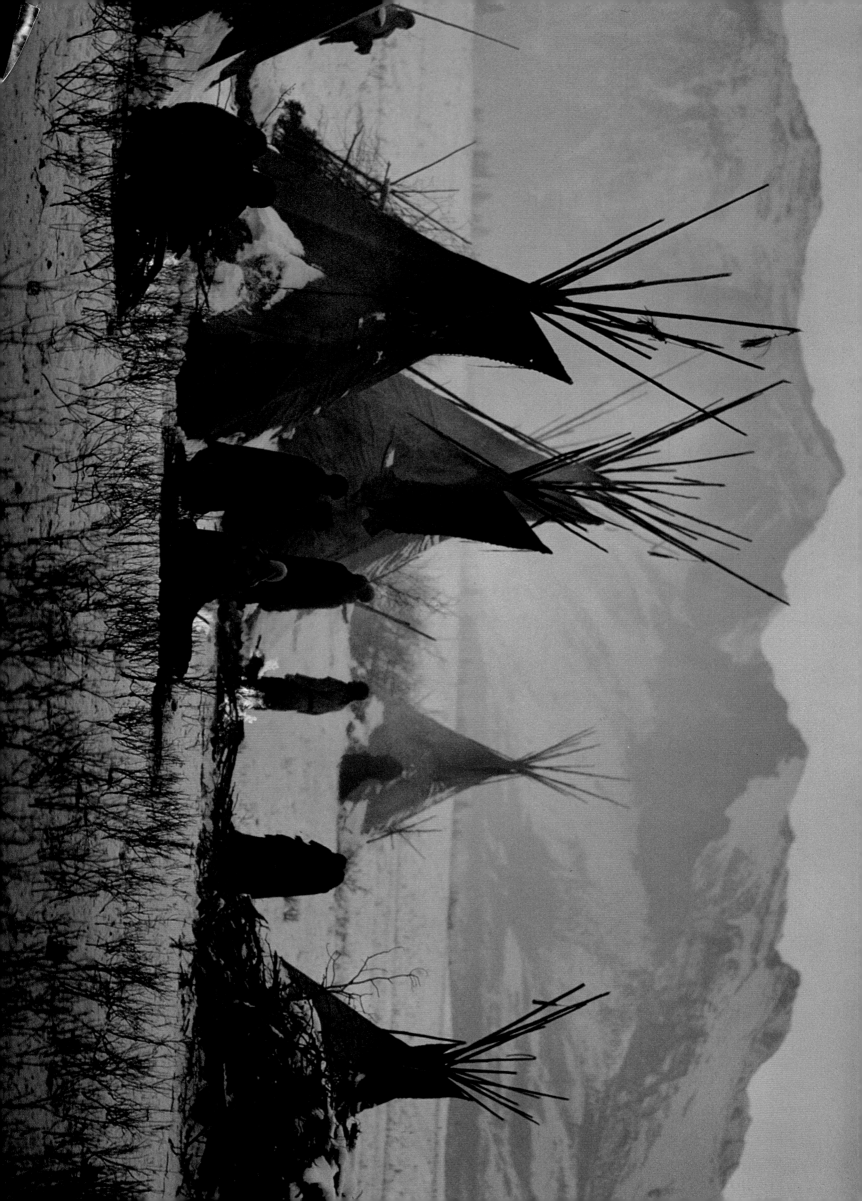

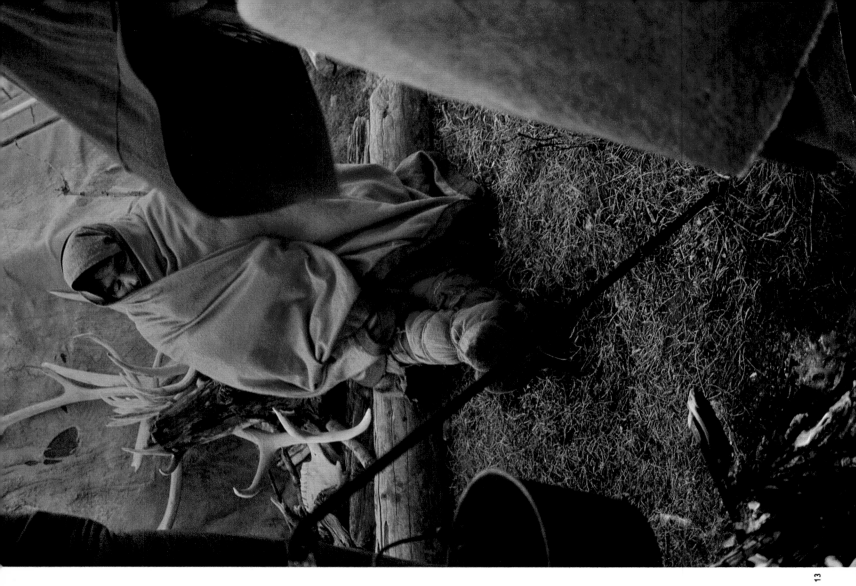

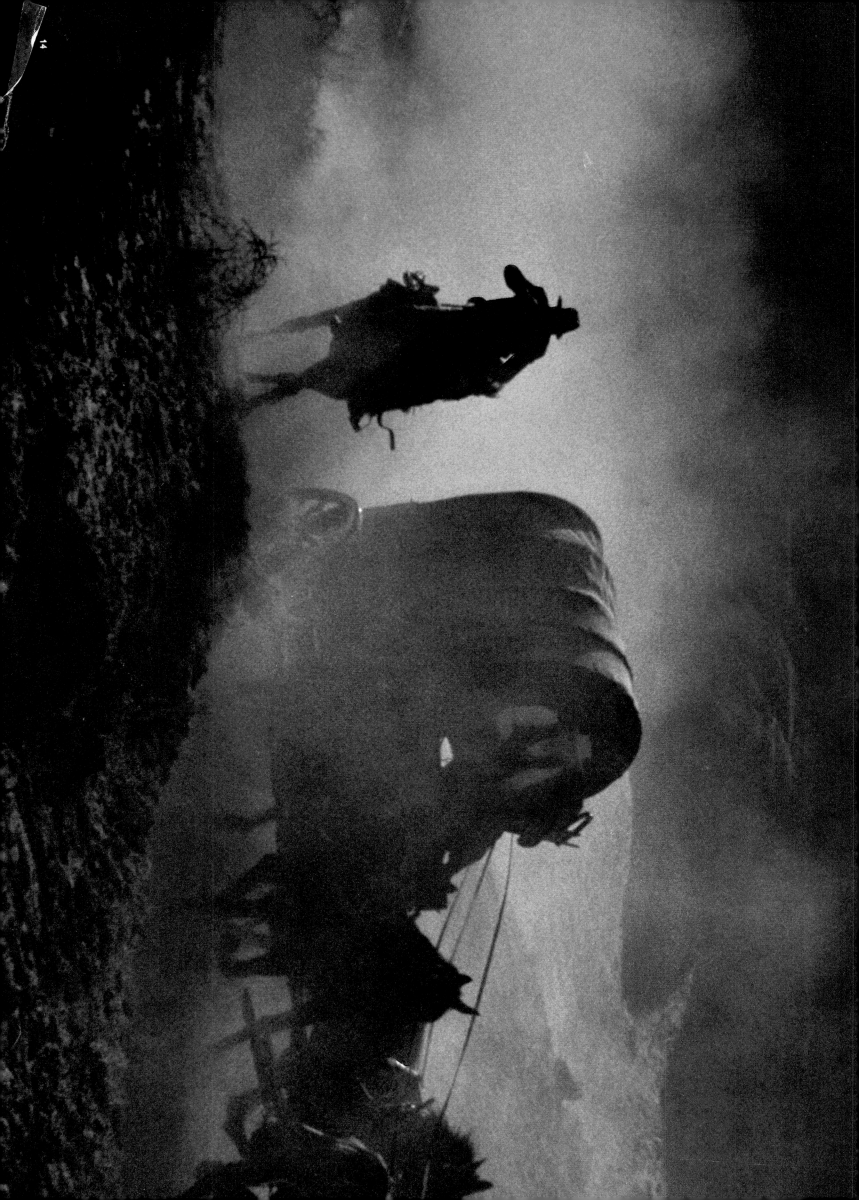

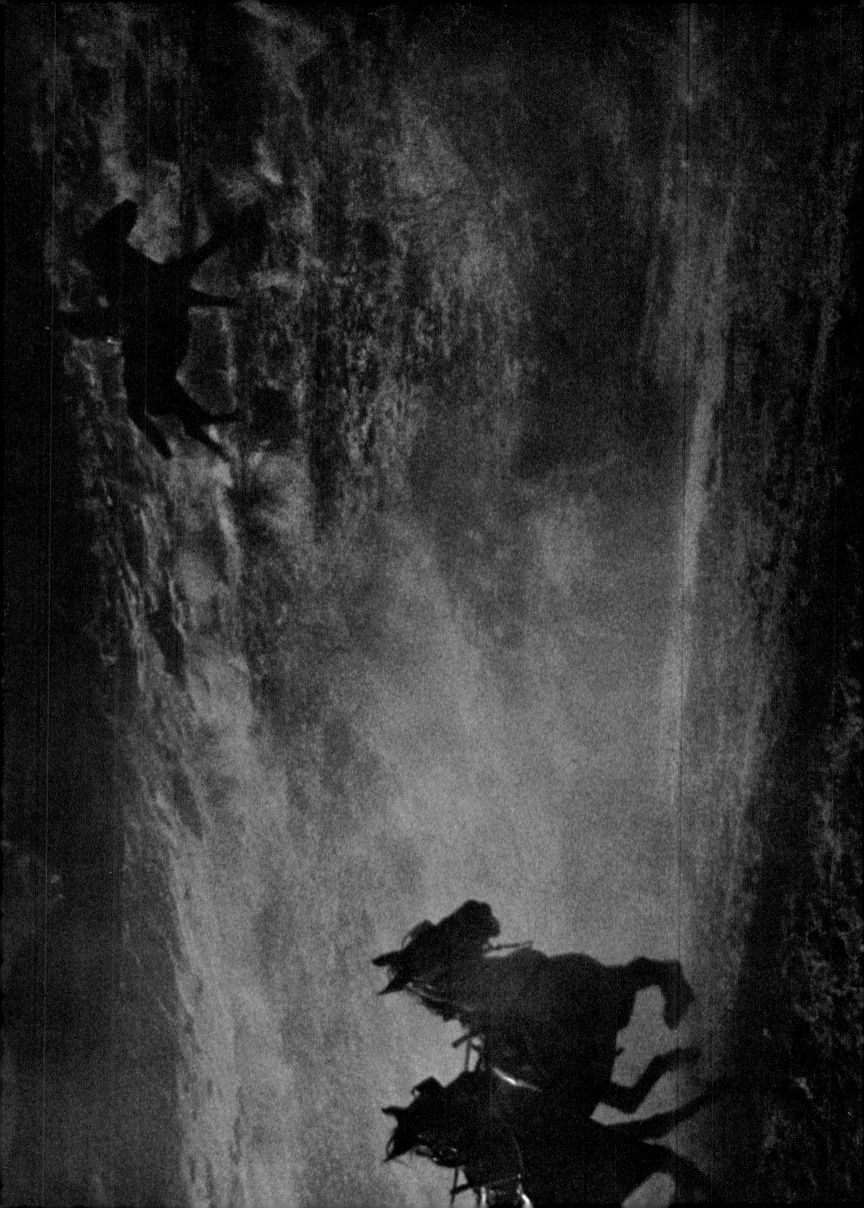

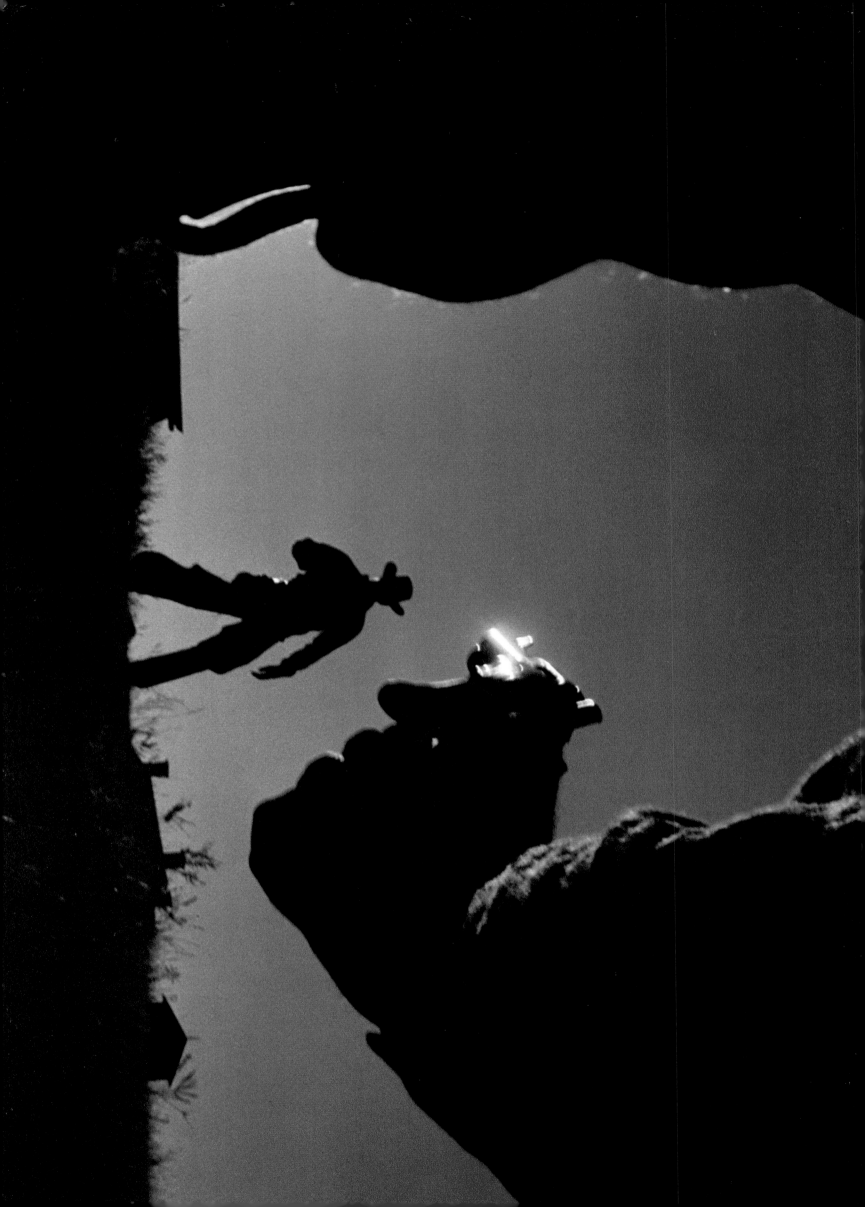

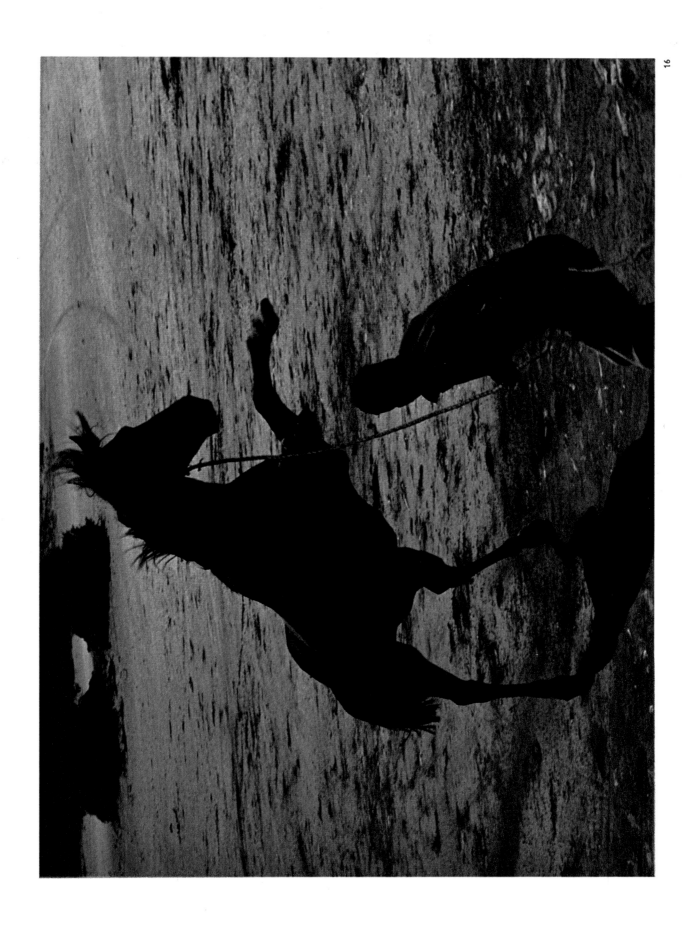

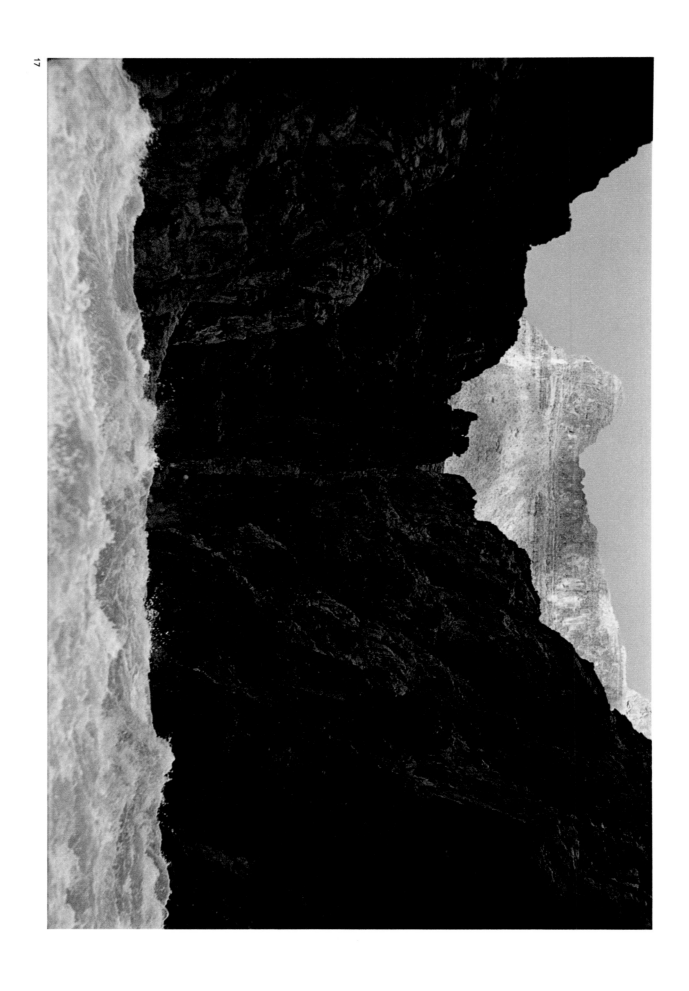

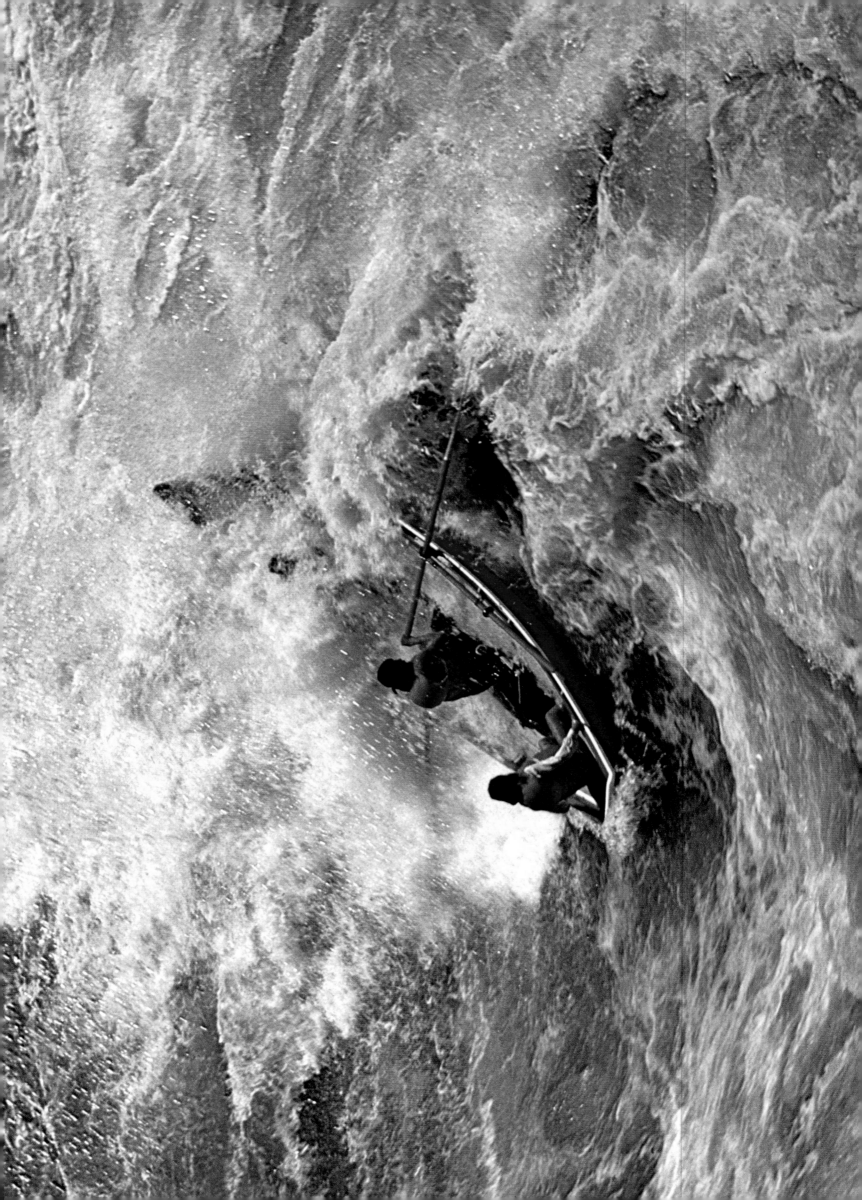

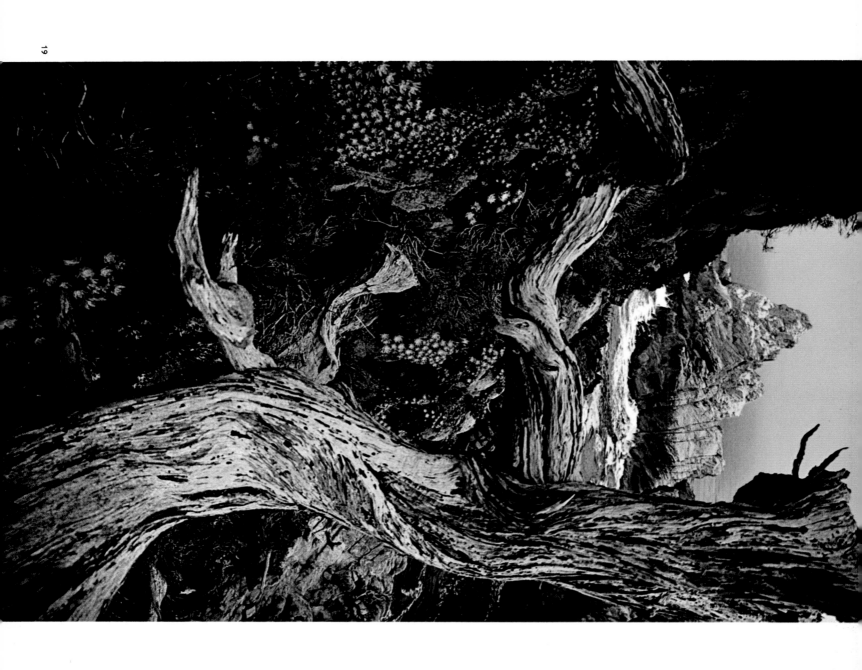

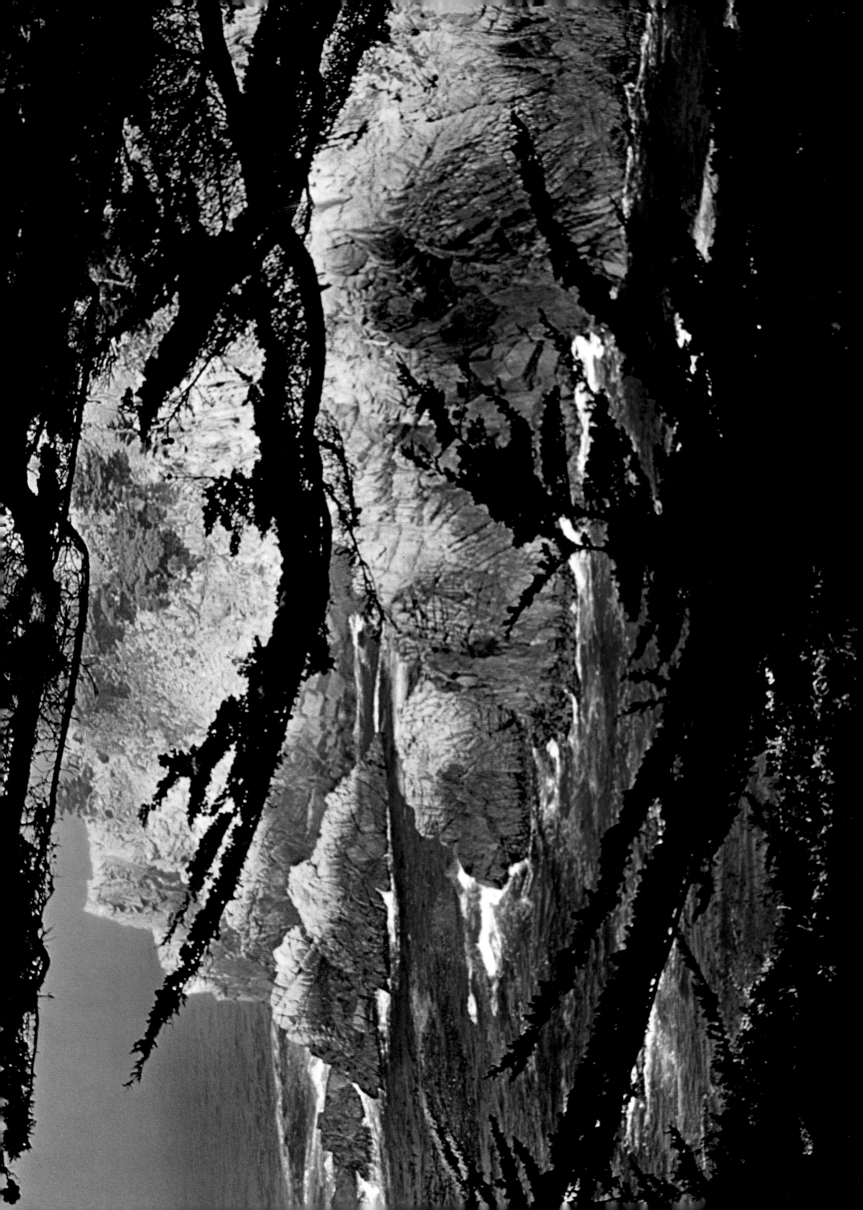

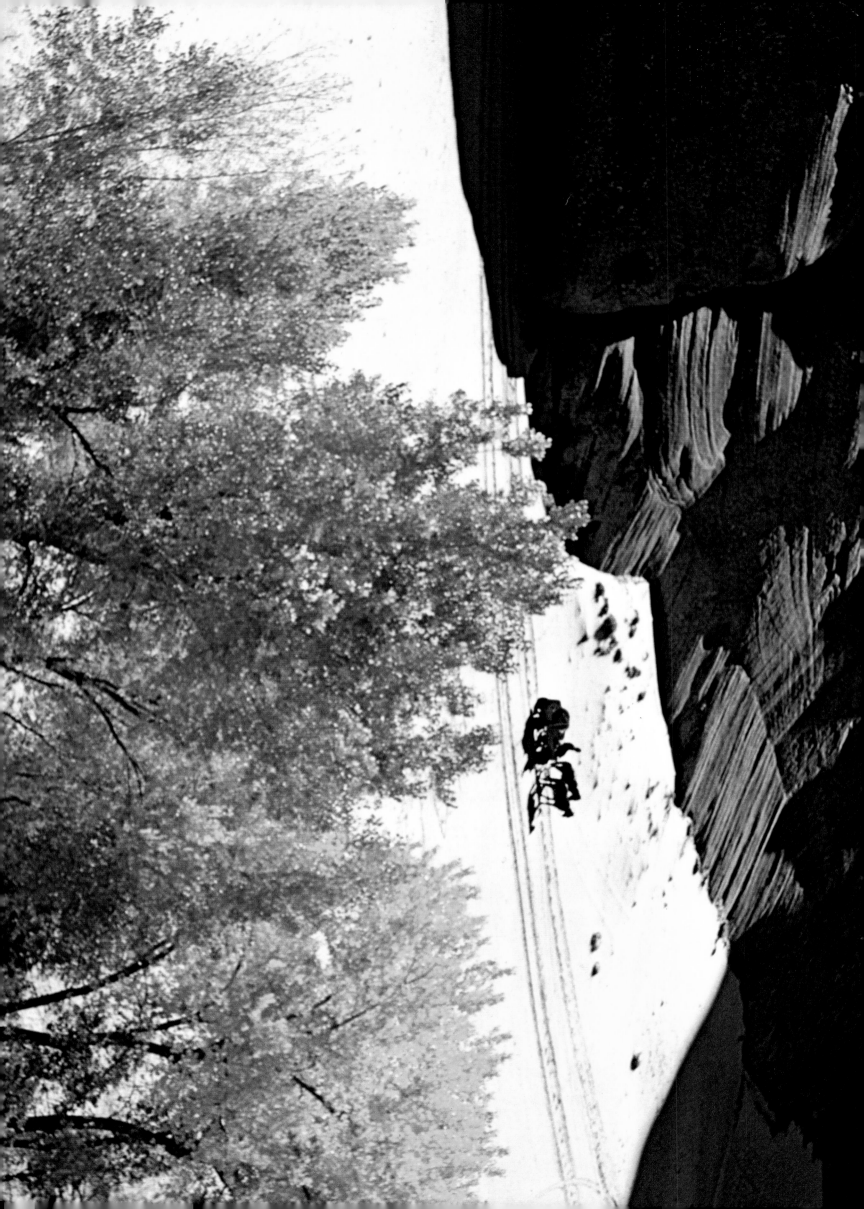

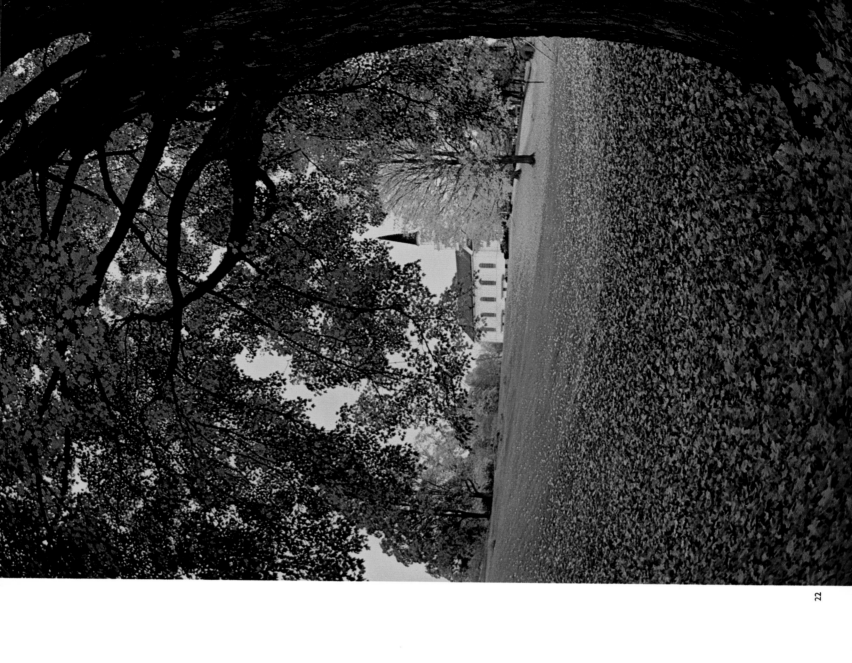

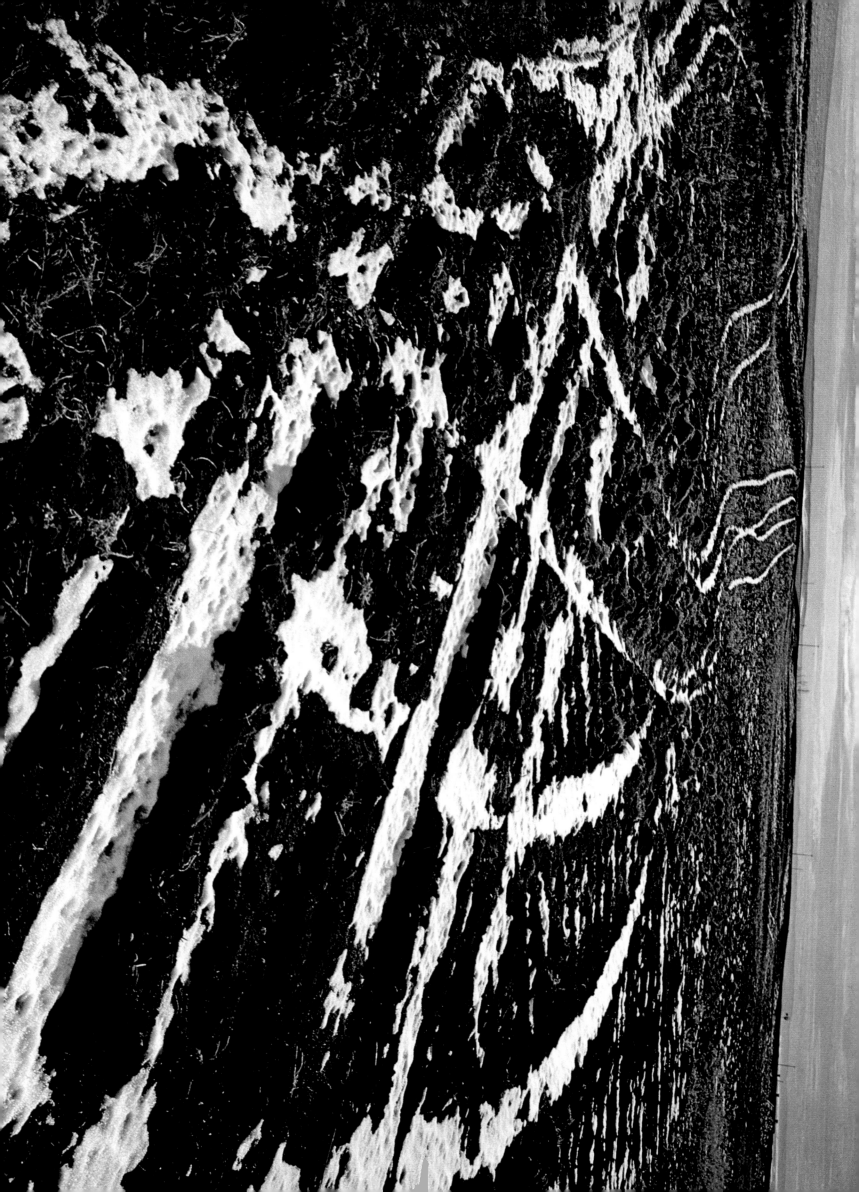

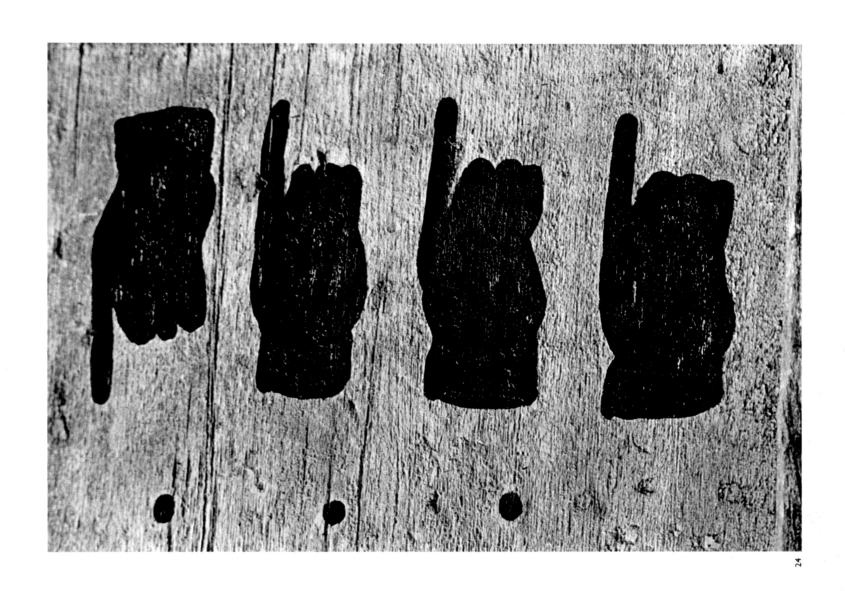

24

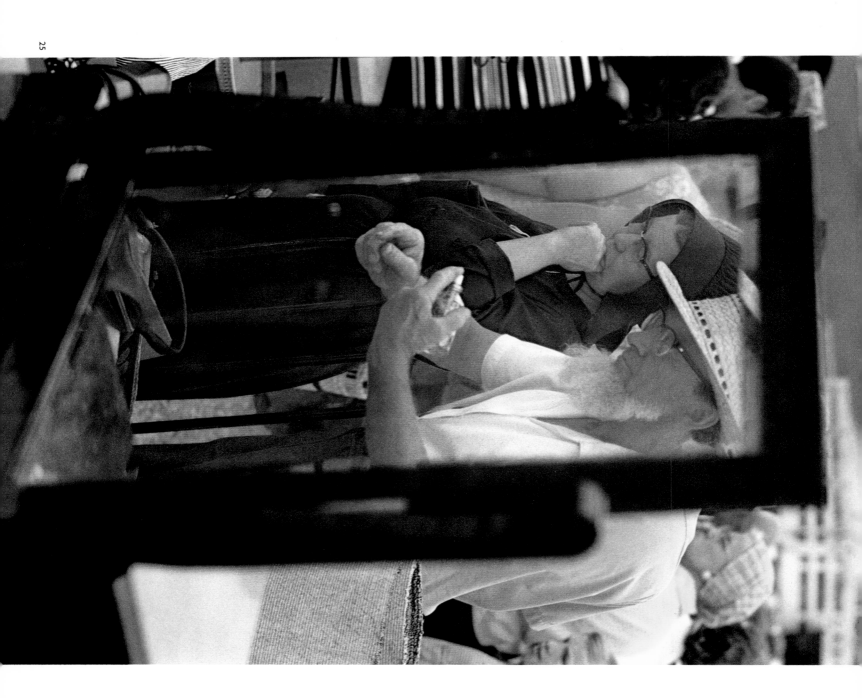

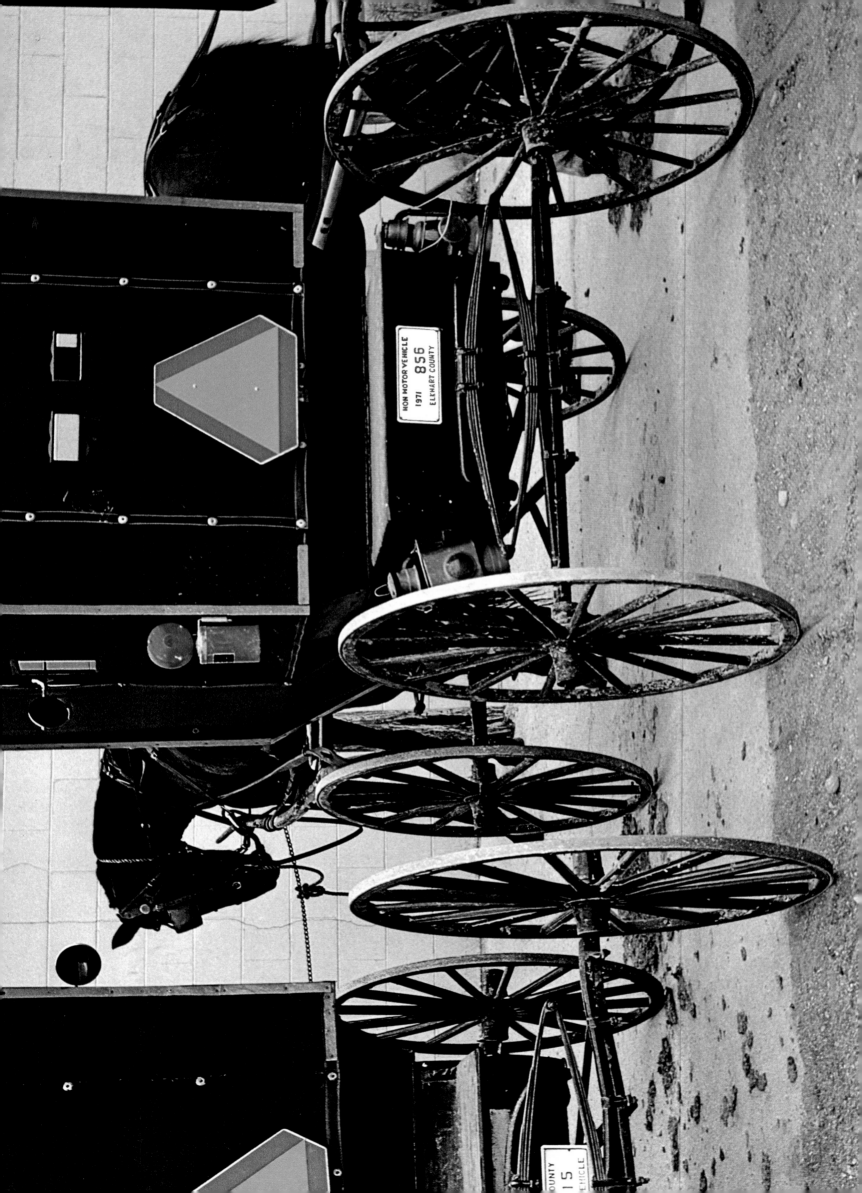

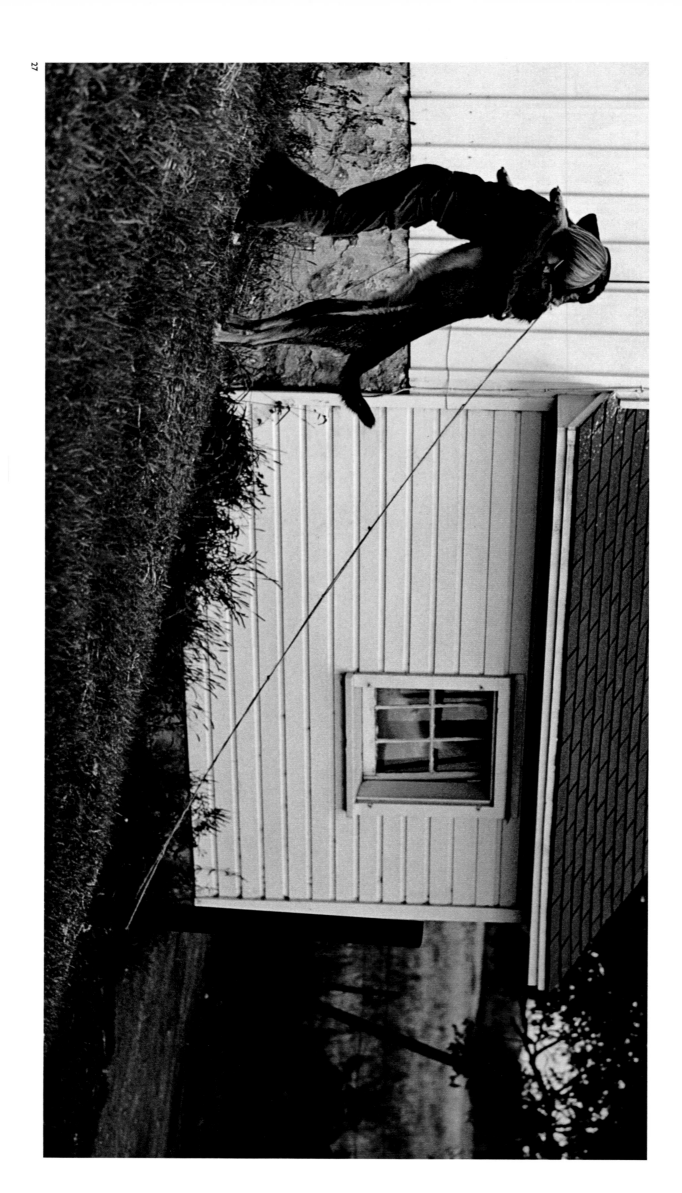

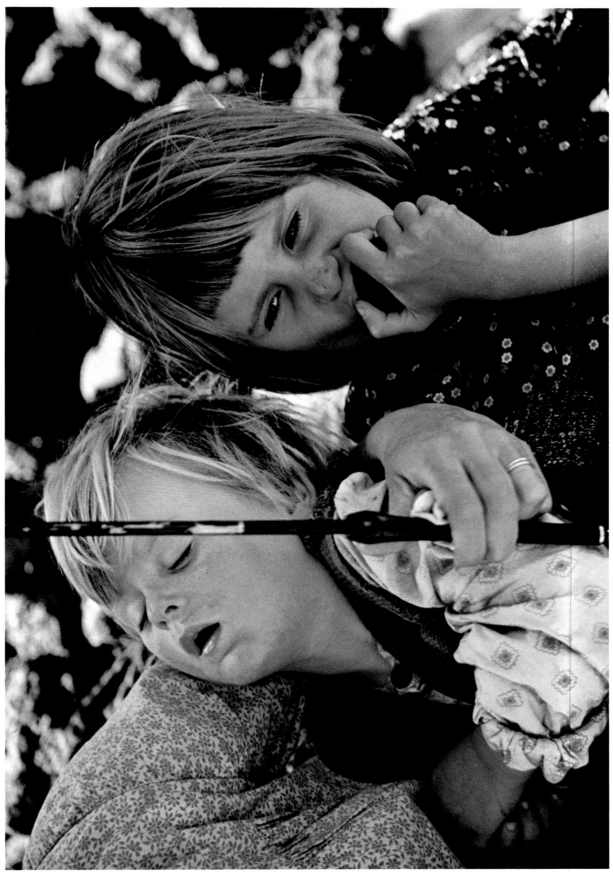

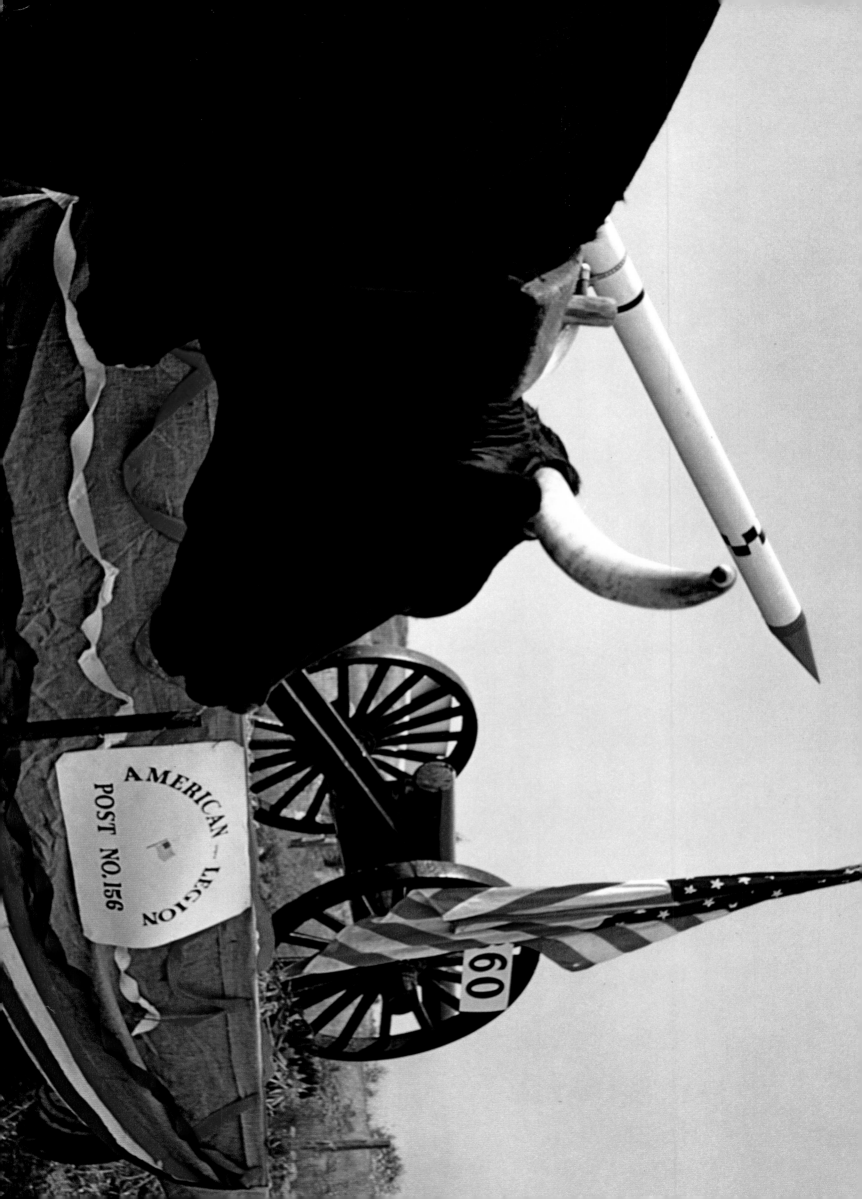

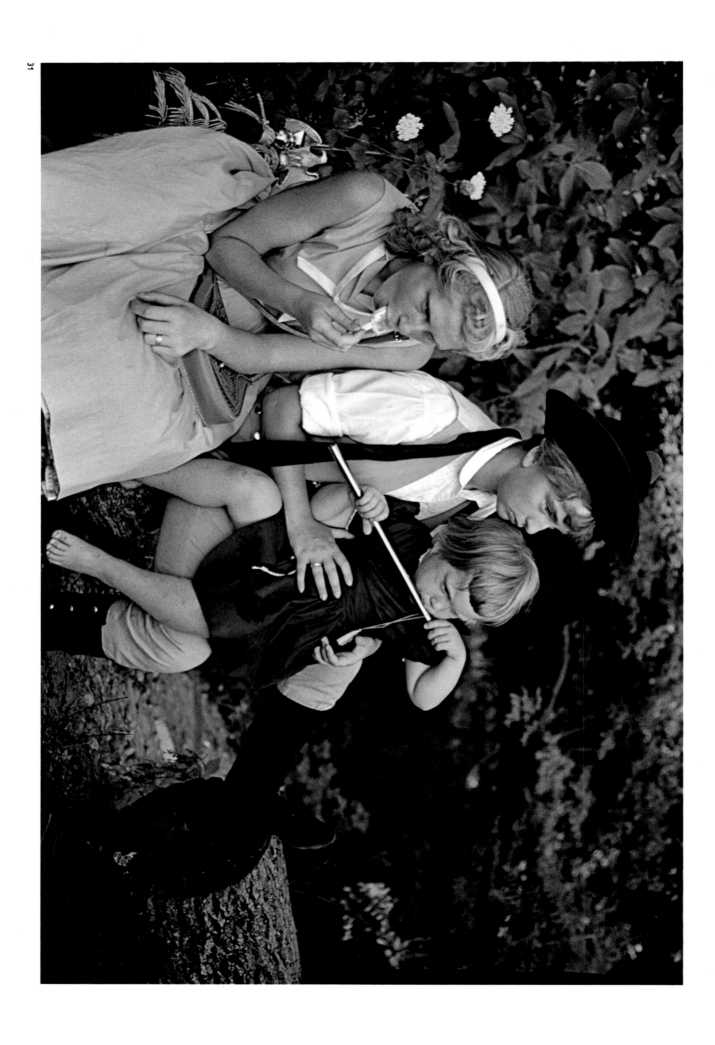

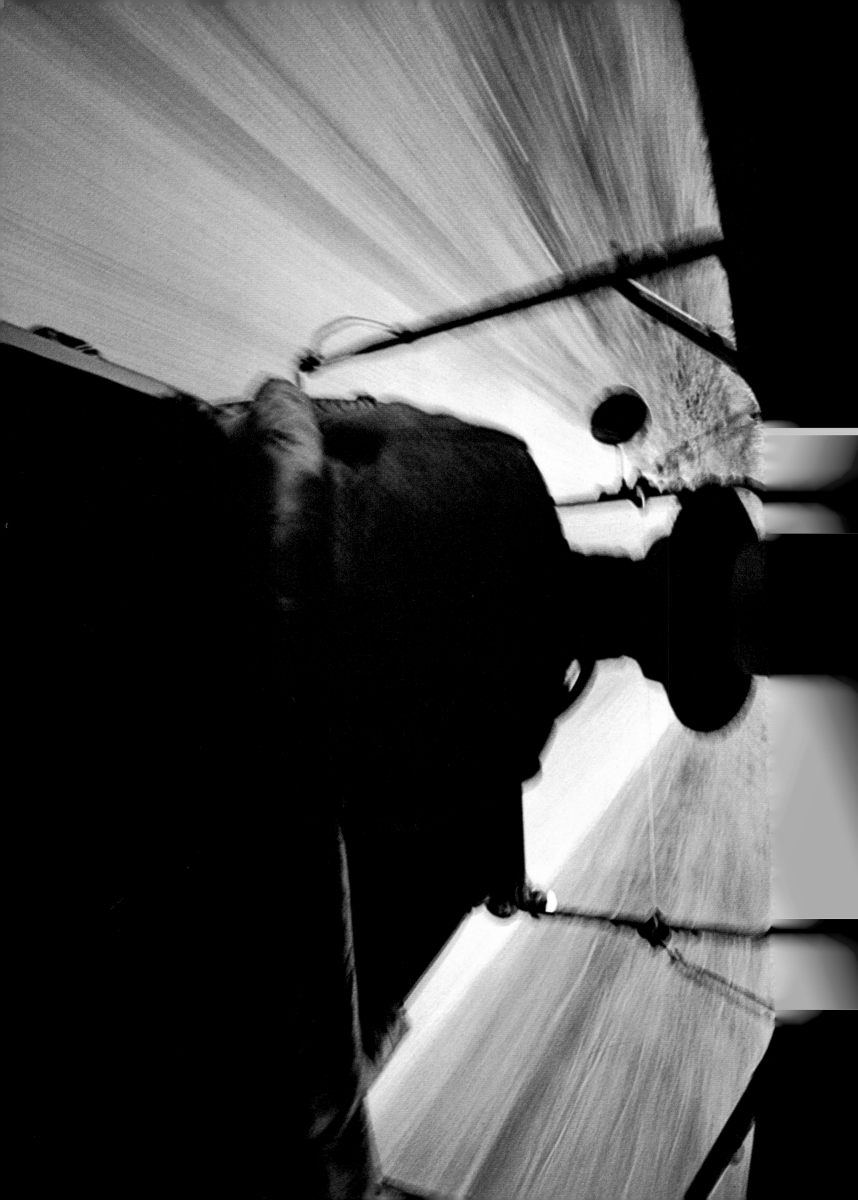

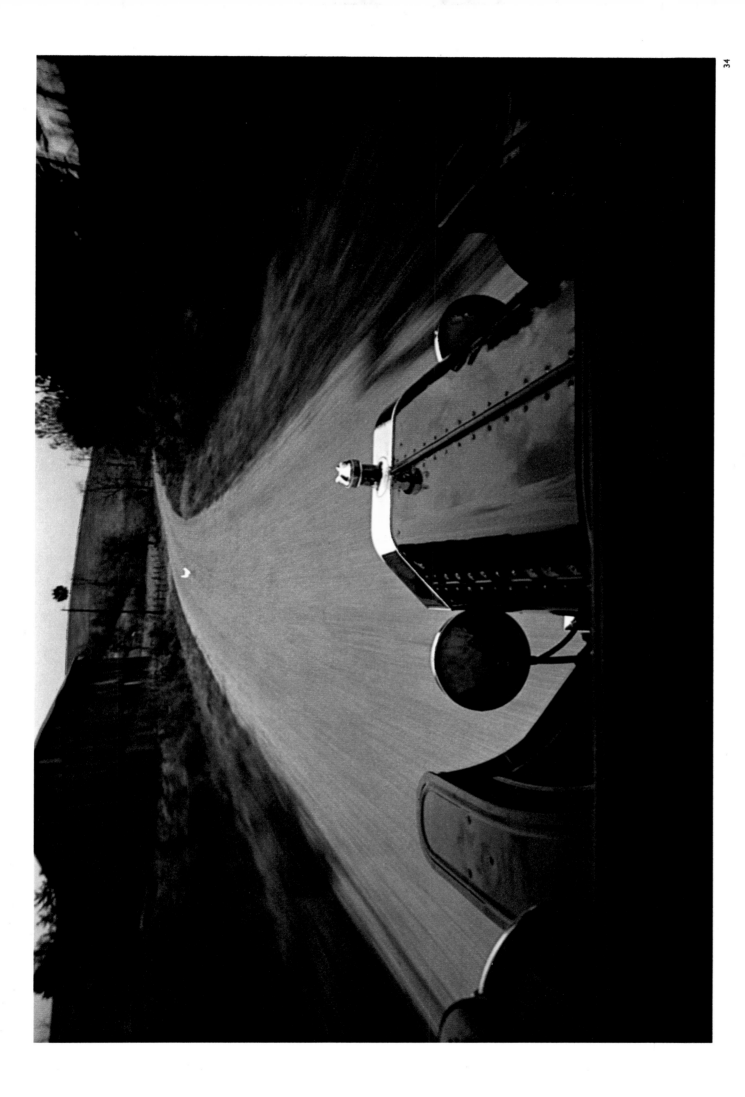

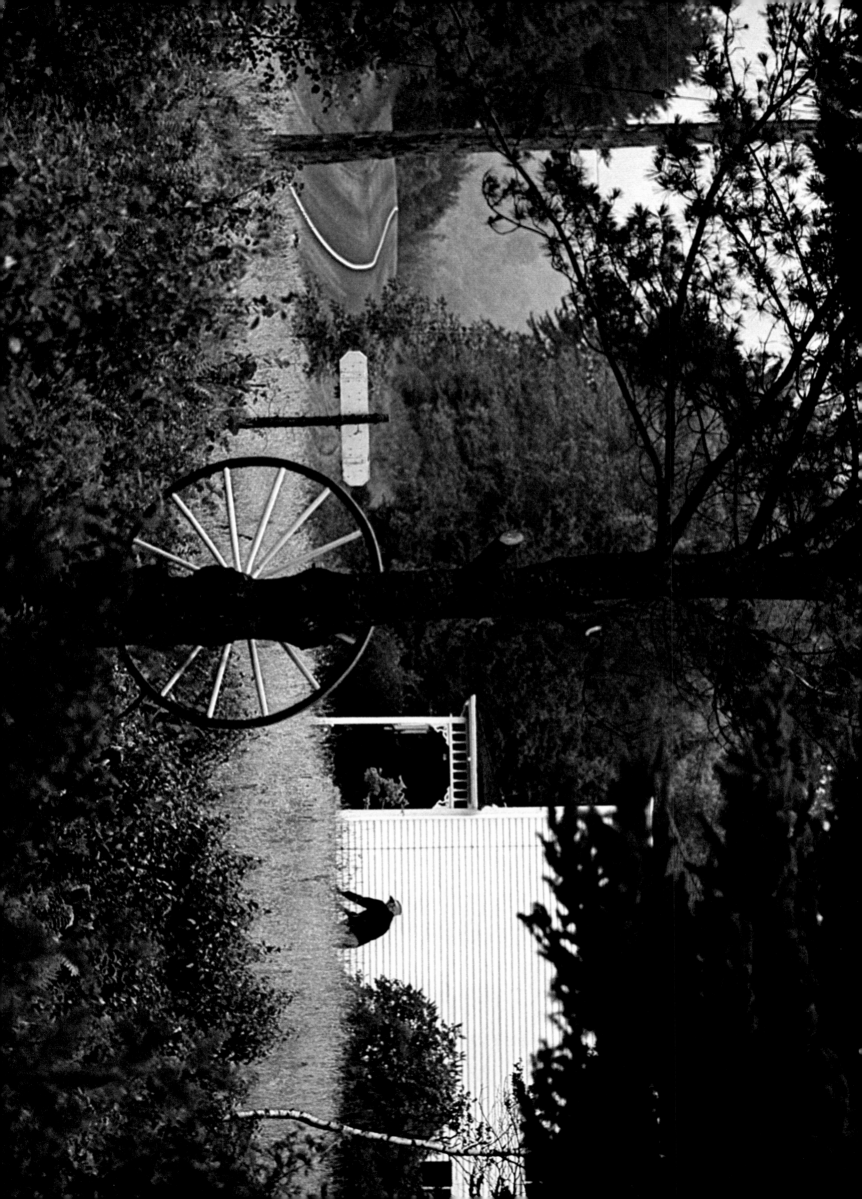

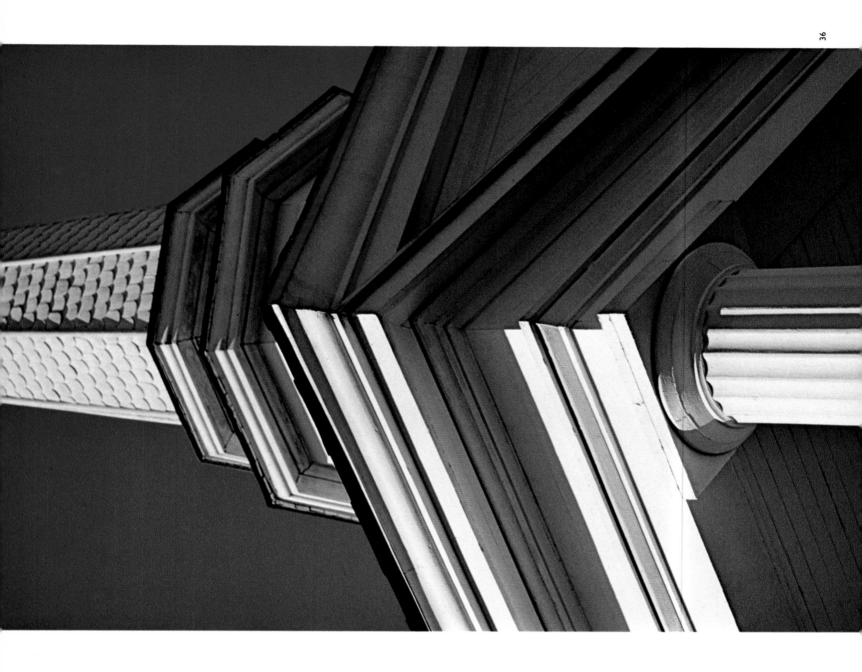

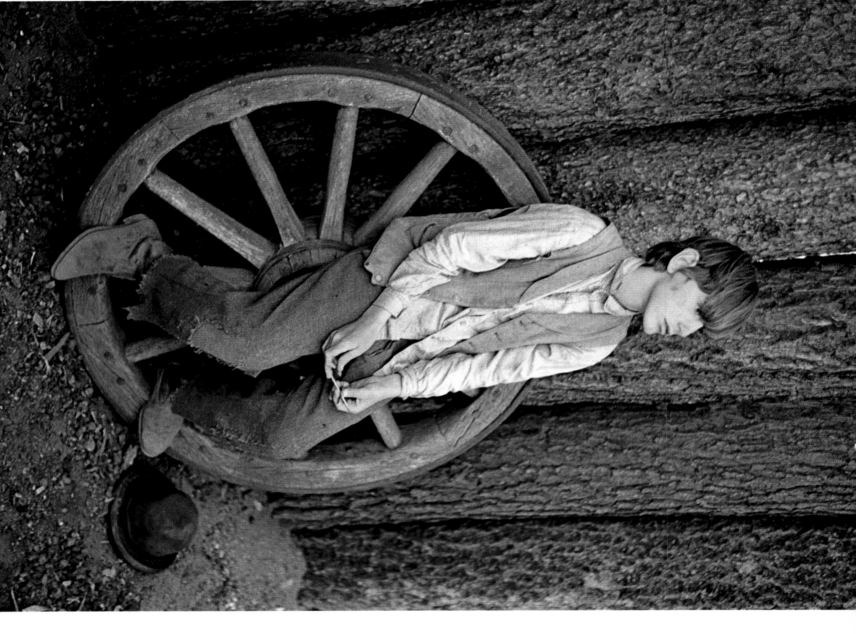

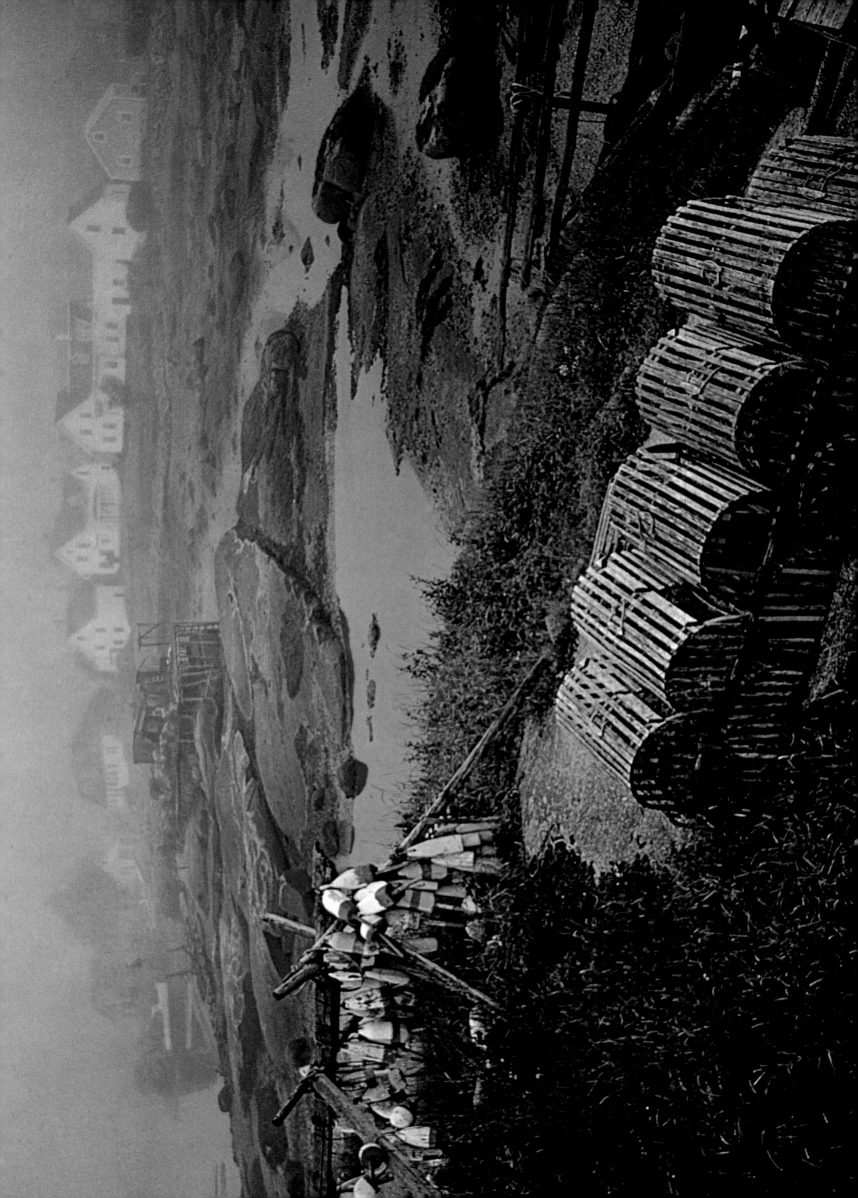

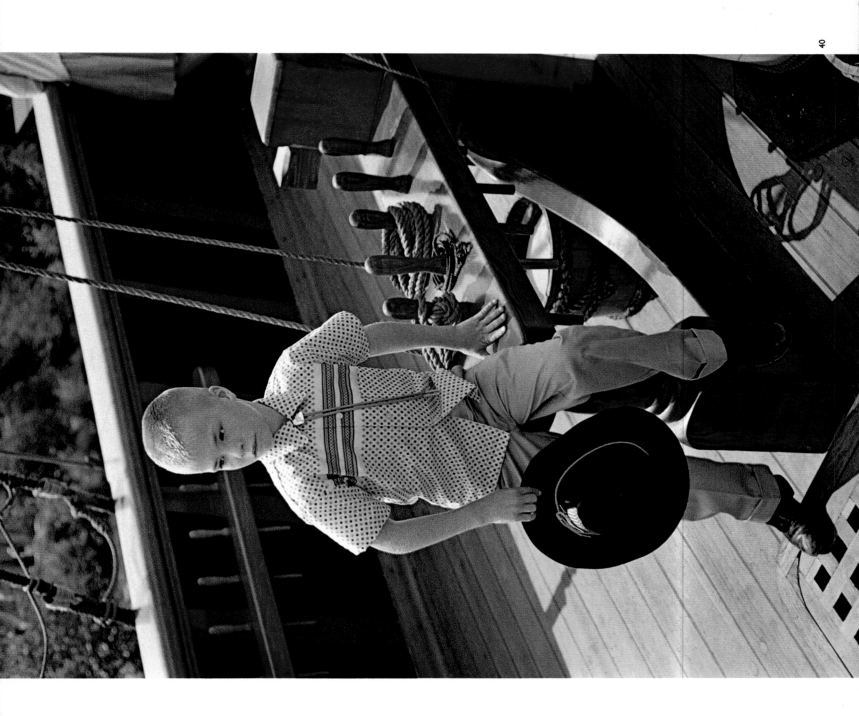

"I AM AN AMERICAN"
MY CREED

"I do not choose to be a common man. It is my right to be uncommon – if I can. I seek opportunity – not security. I do not wish to be a kept citizen, humbled and dulled by having the state look after me. I want to take the calculated risk, to dream and to build, to fall and to succeed. I refuse to barter incentive for a dole. I prefer the challenge of life to the guaranteed calm of utopia. **I WILL NOT TRADE FREE-DOM FOR BENEFICENCE NOR MY DIGNITY FOR A HAND-OUT.** It is my heritage to think and act for myself, enjoy the benefit of my creations, and to face the world boldly and say, this I have done. All this is what it means to be an American."

— Dean Alfange.

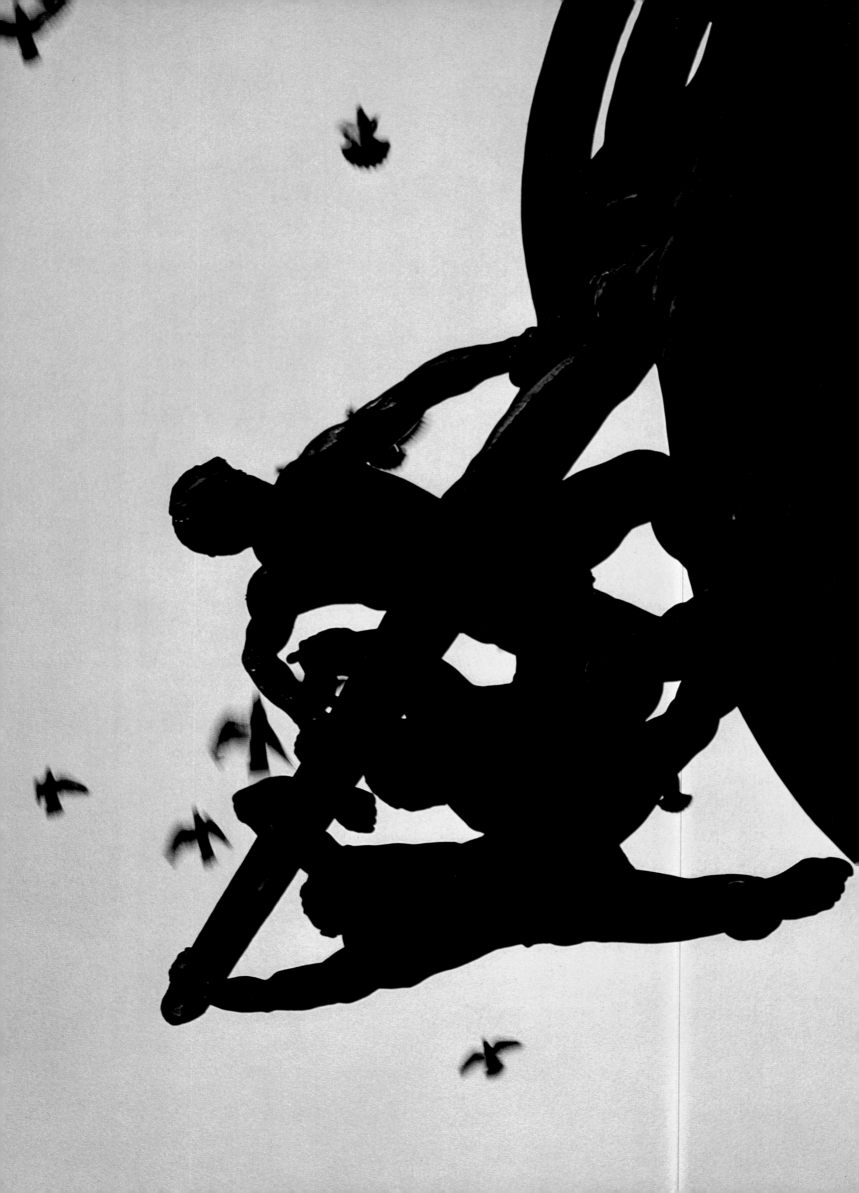

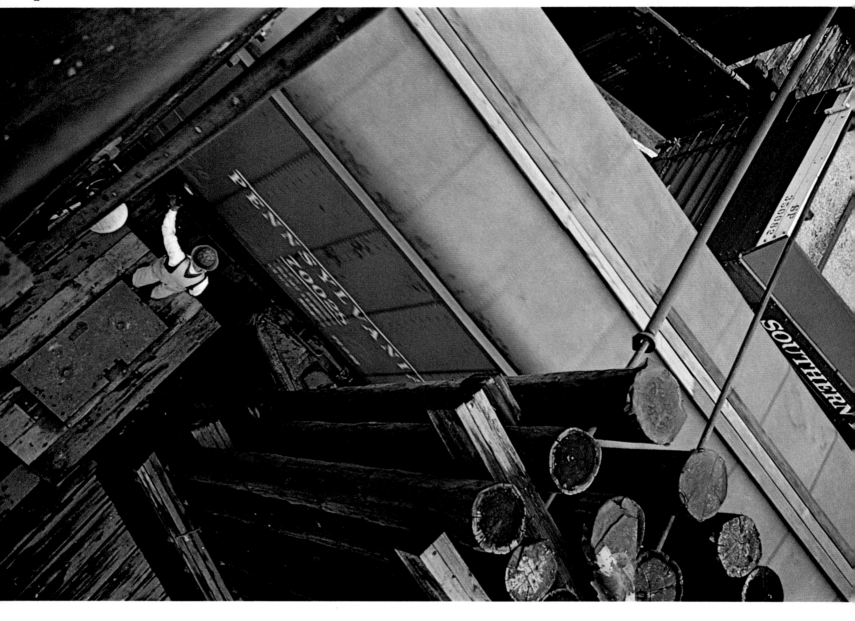

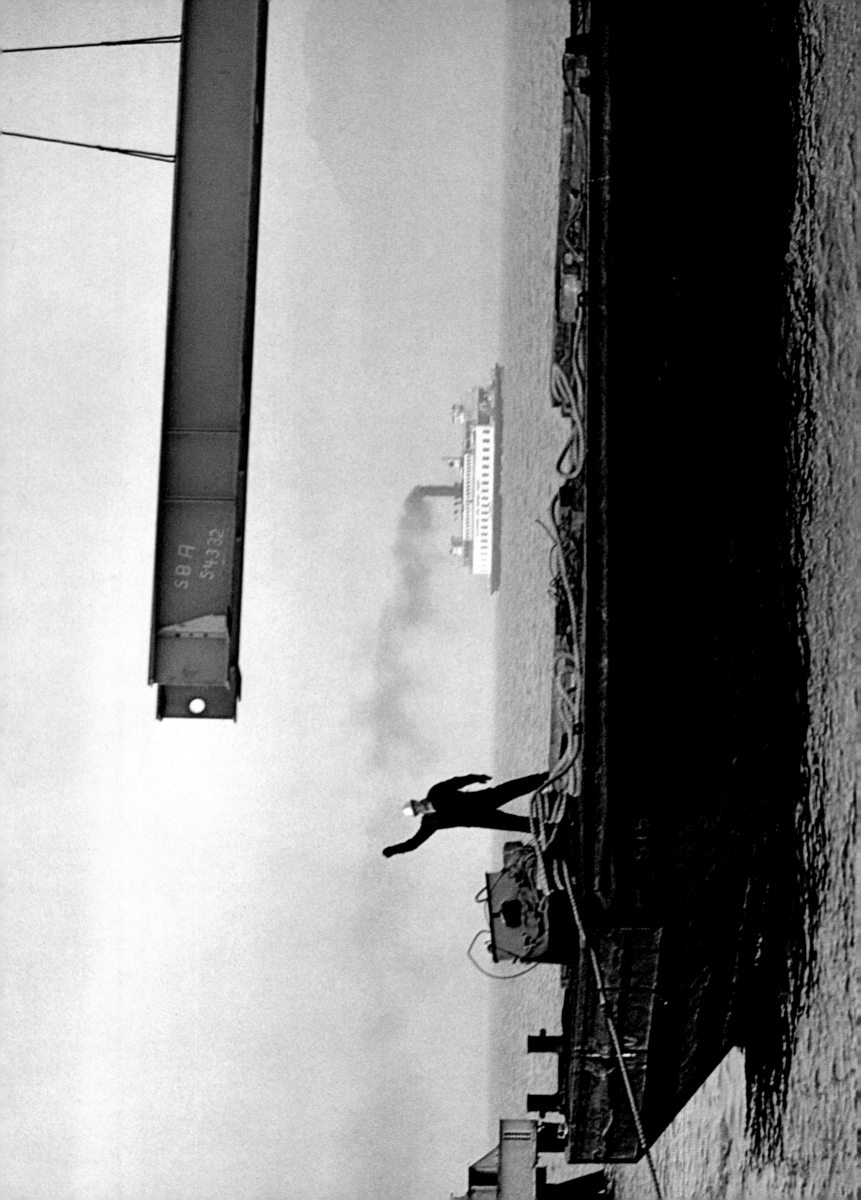

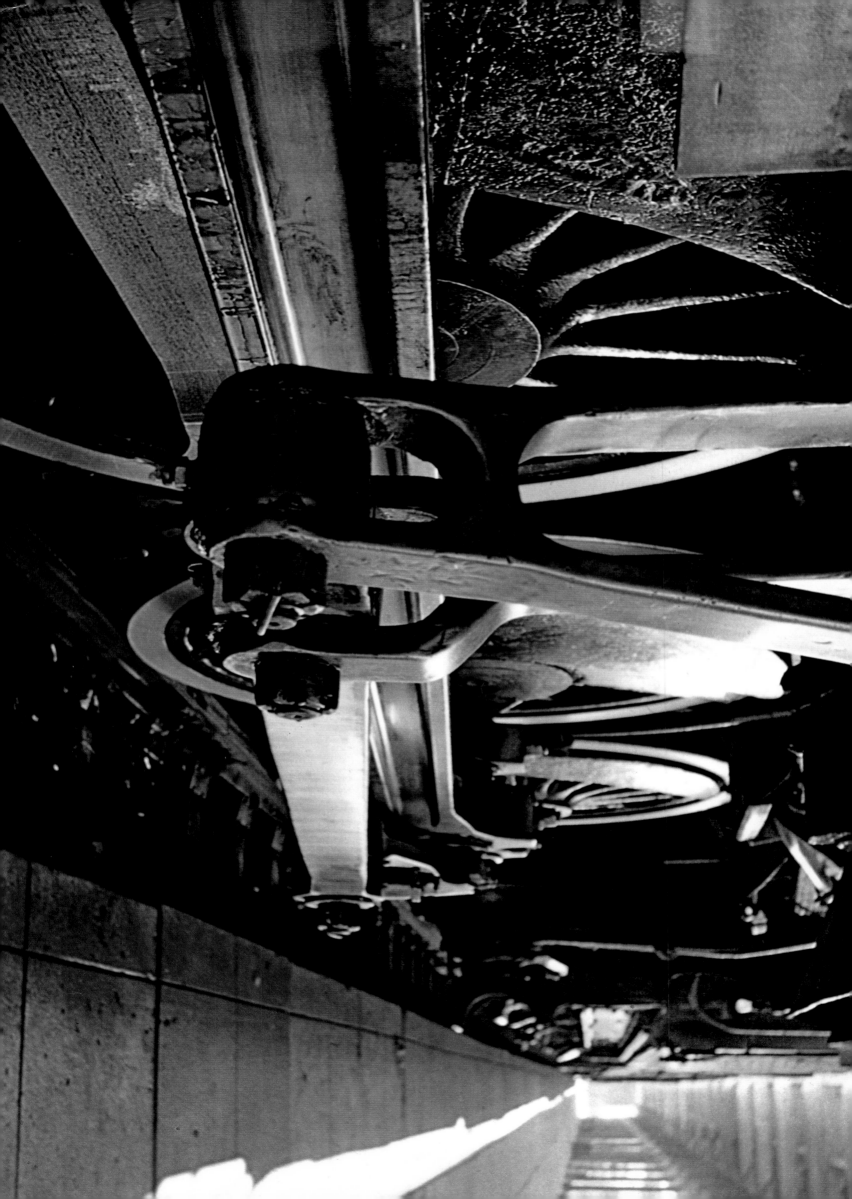

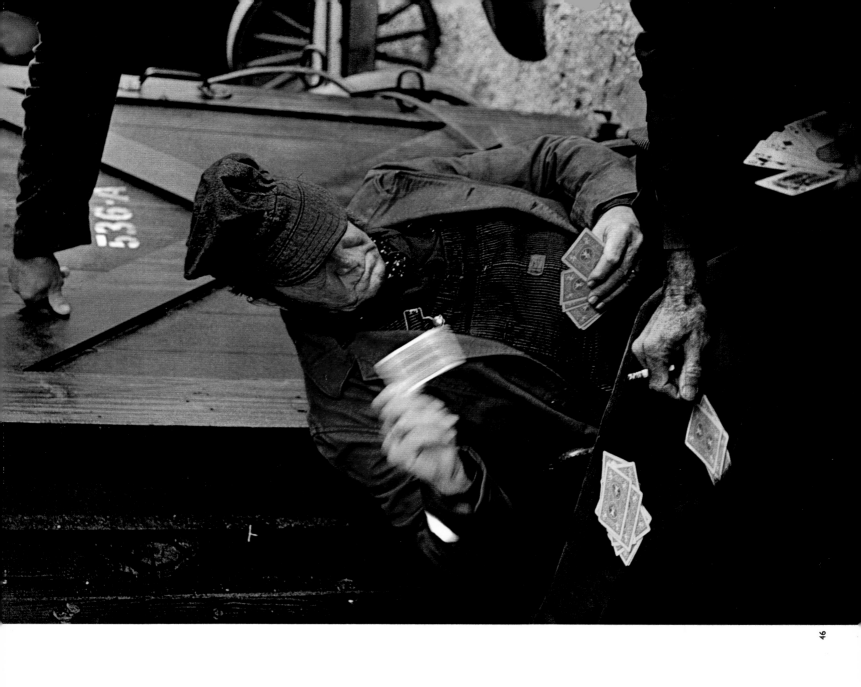

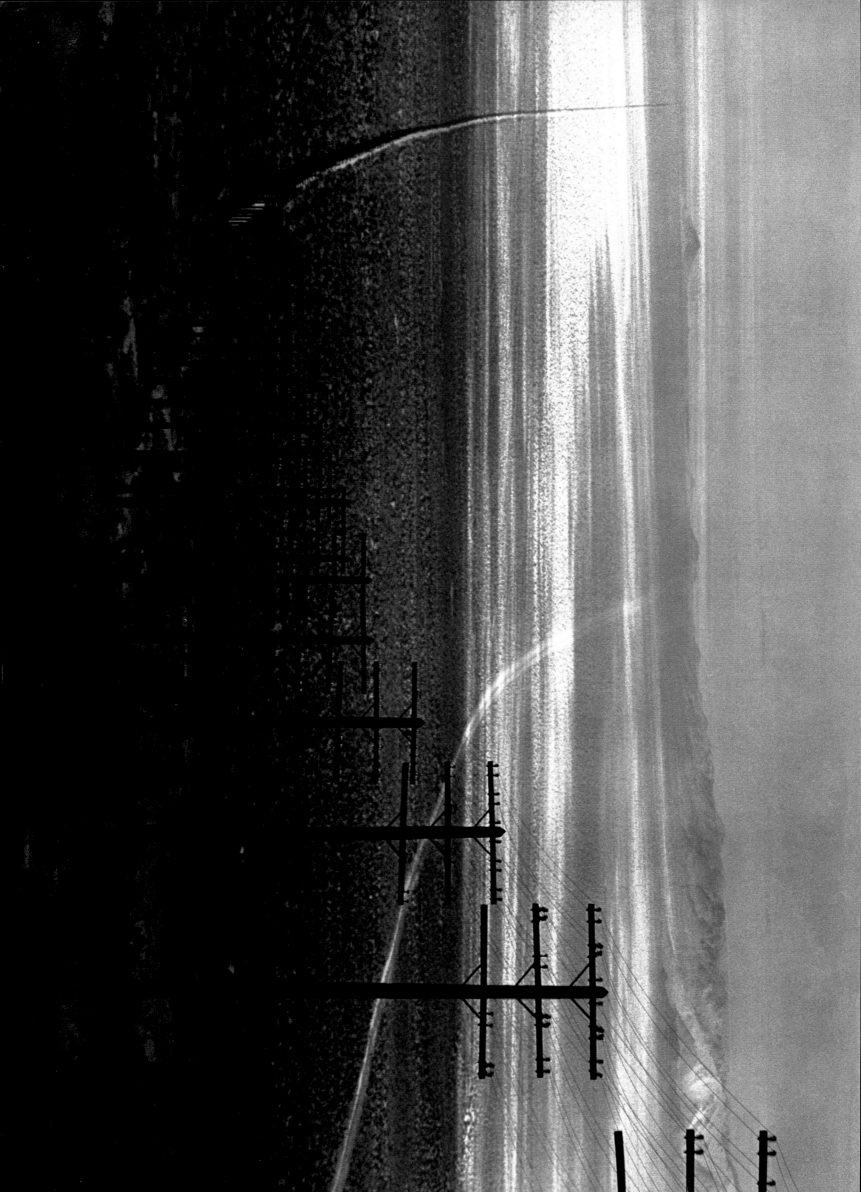

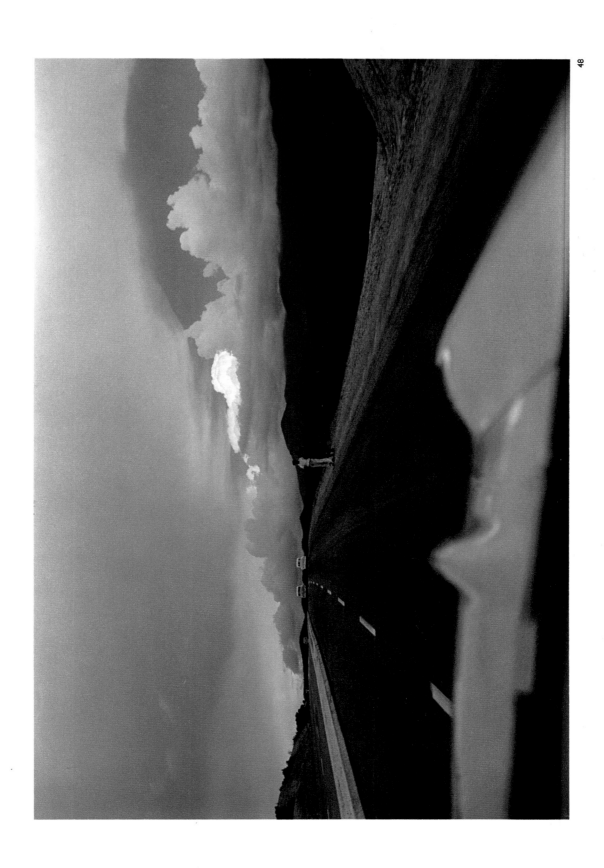

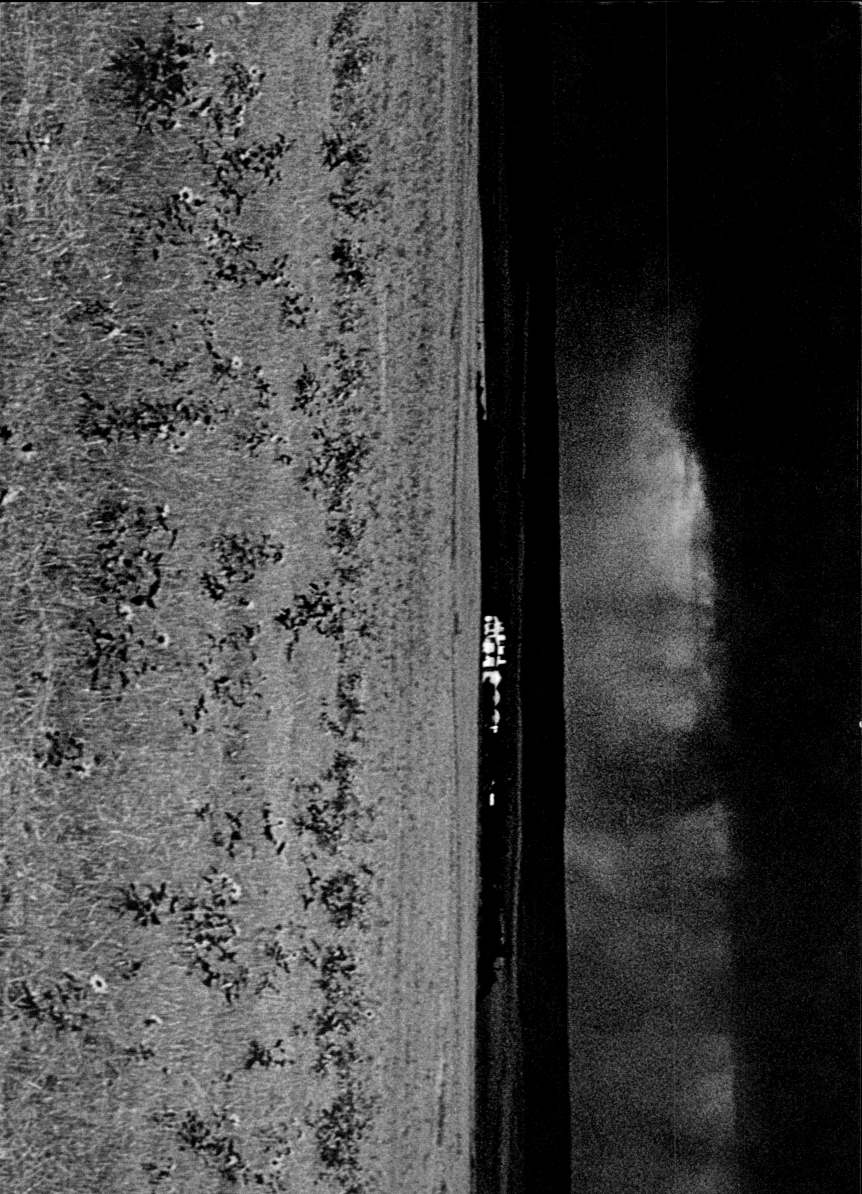

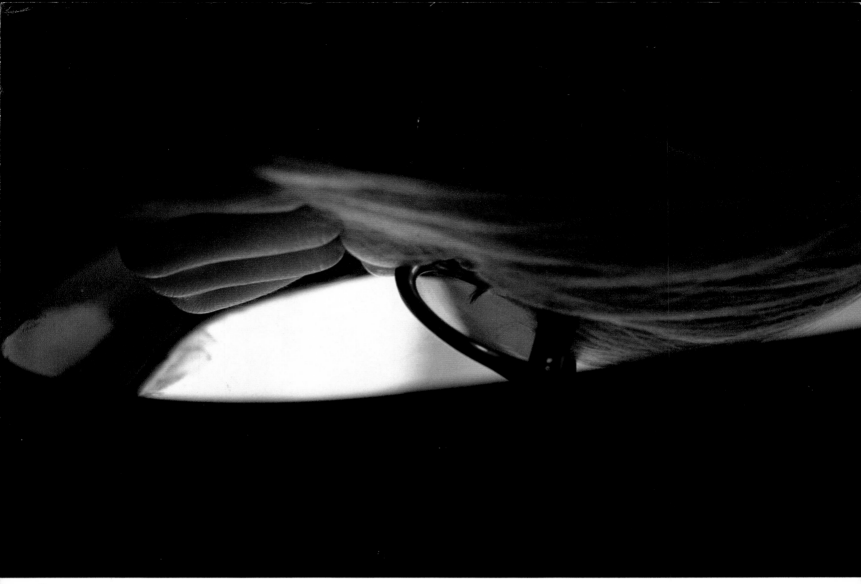

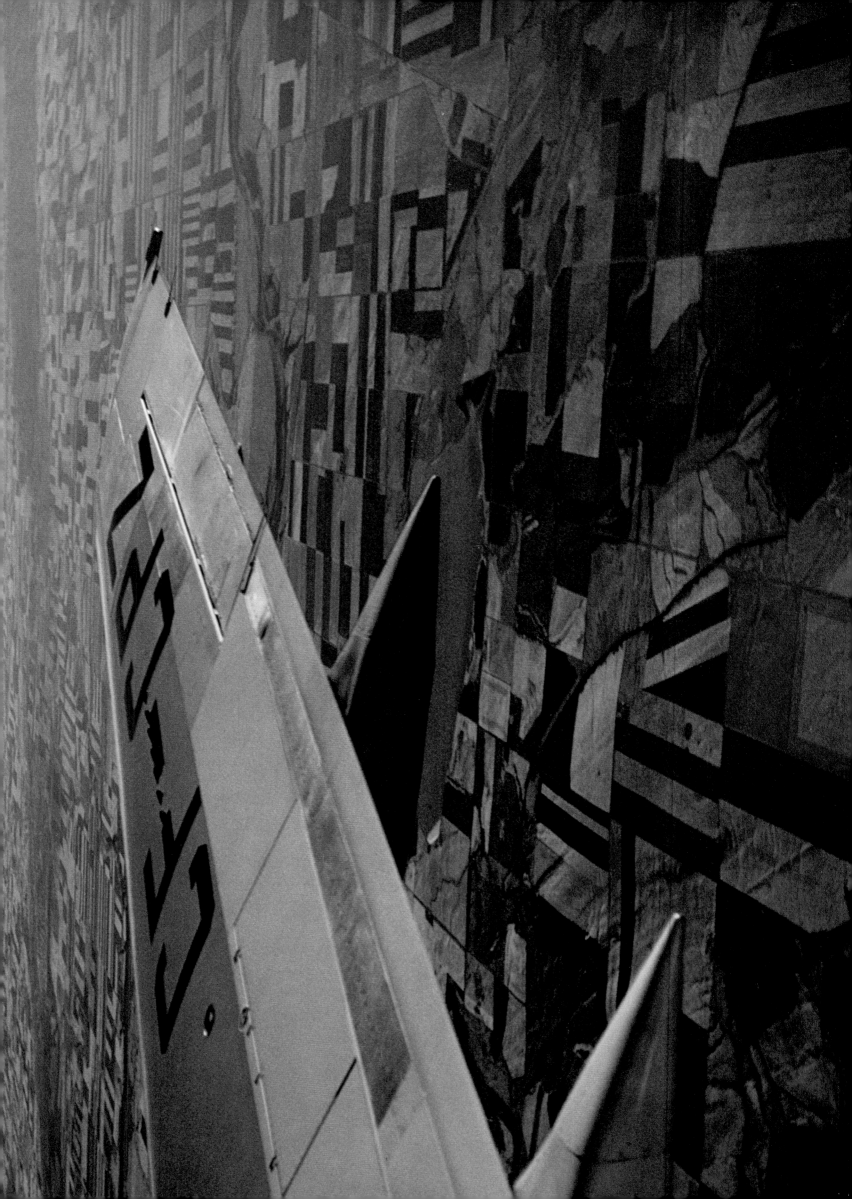

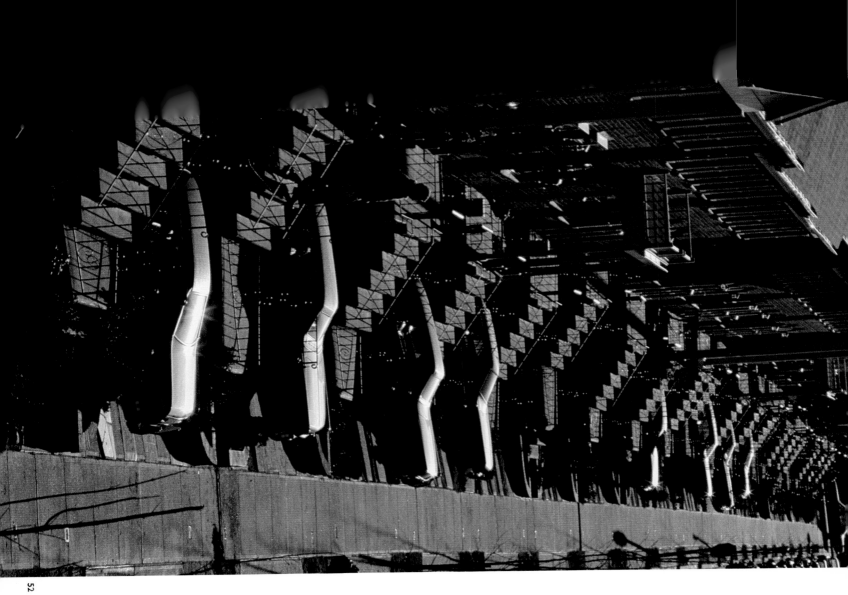

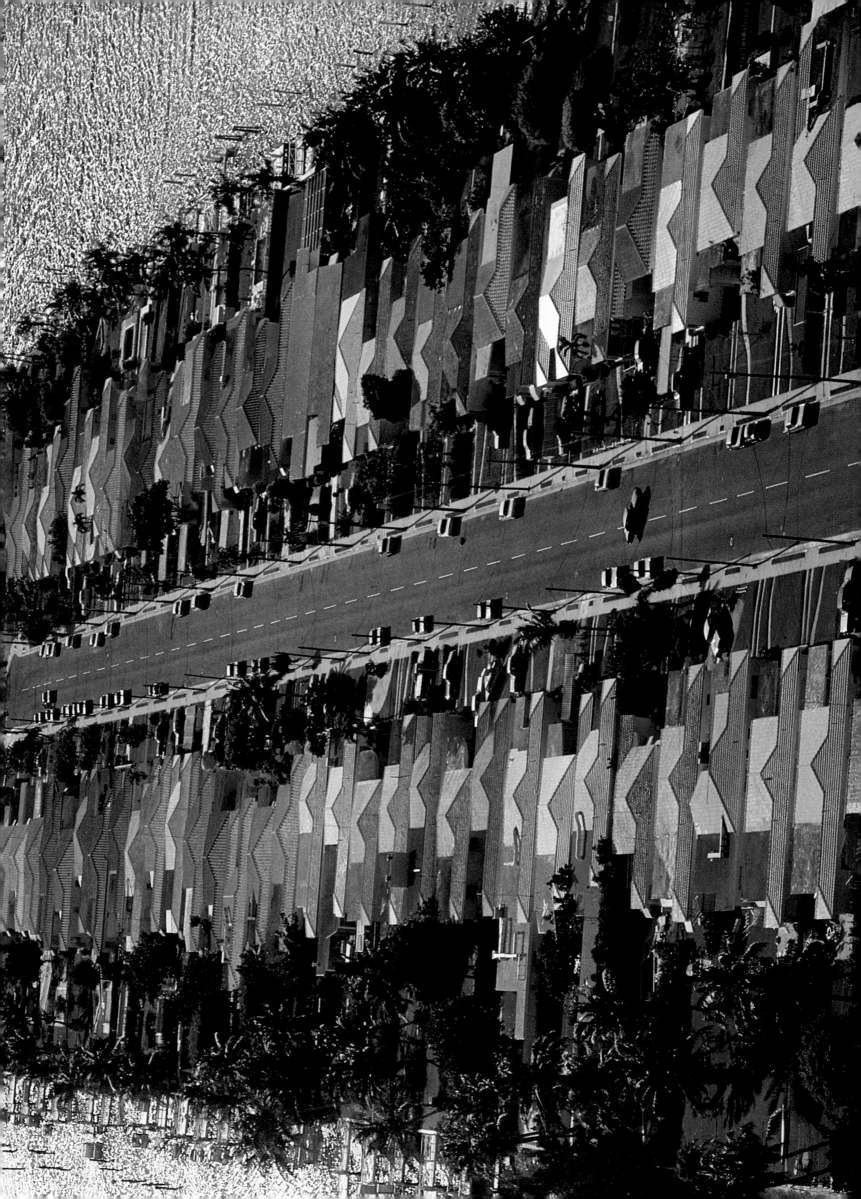

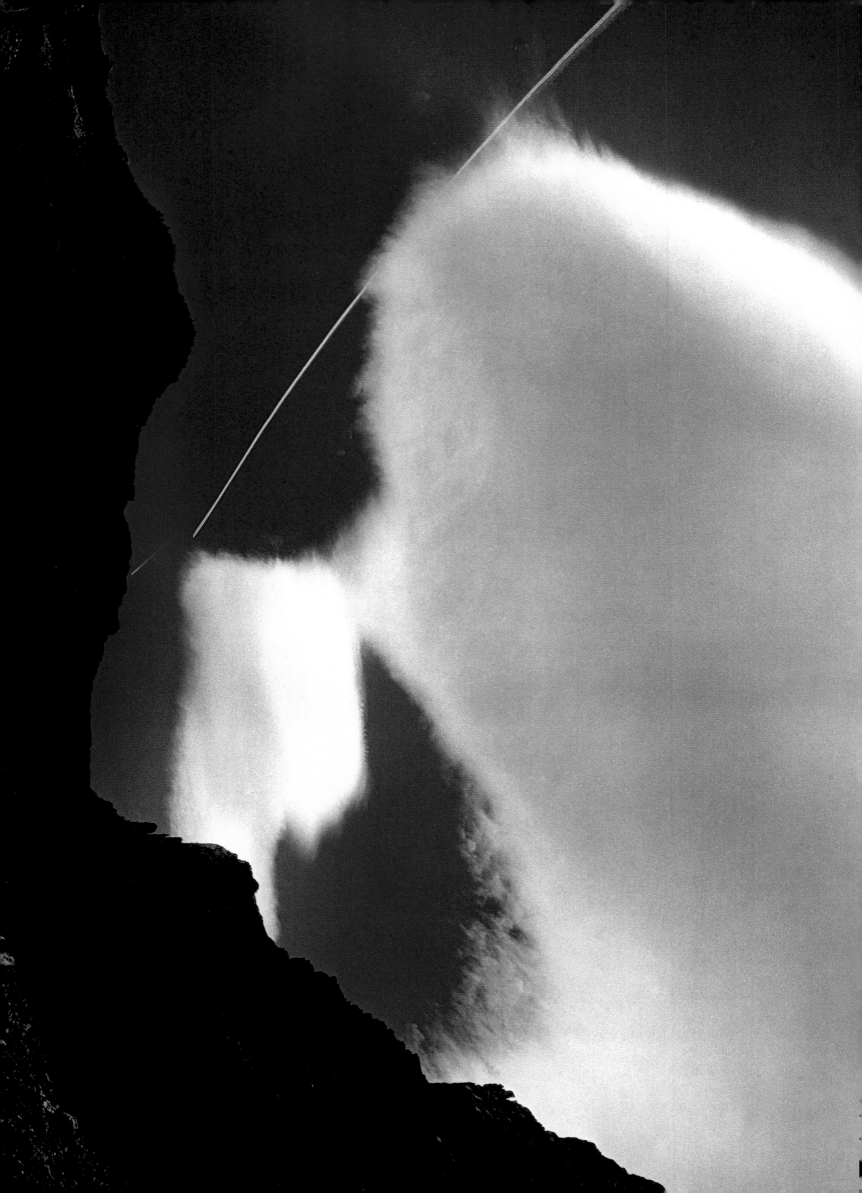

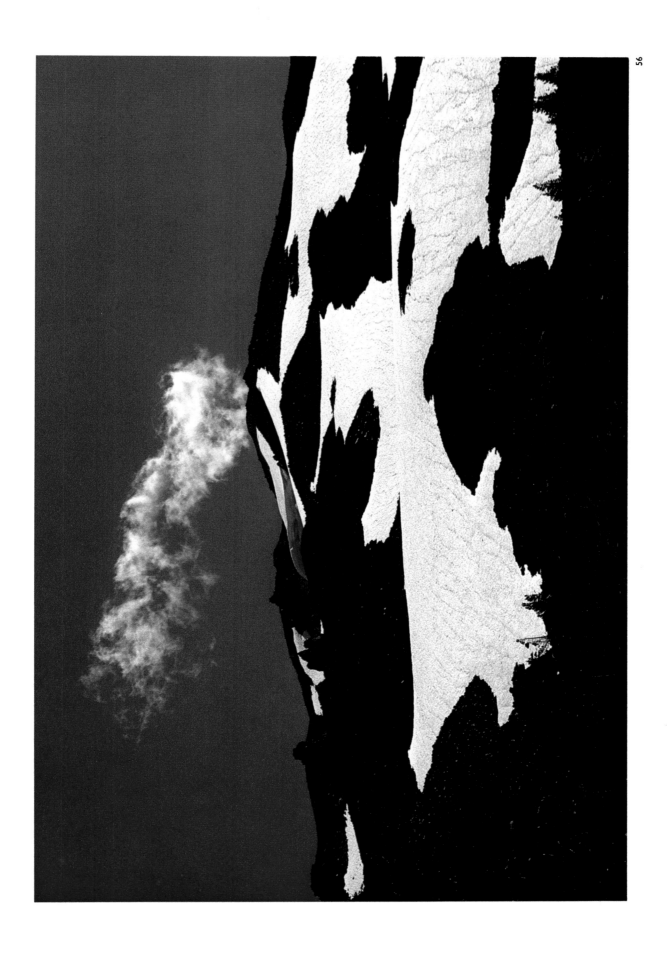

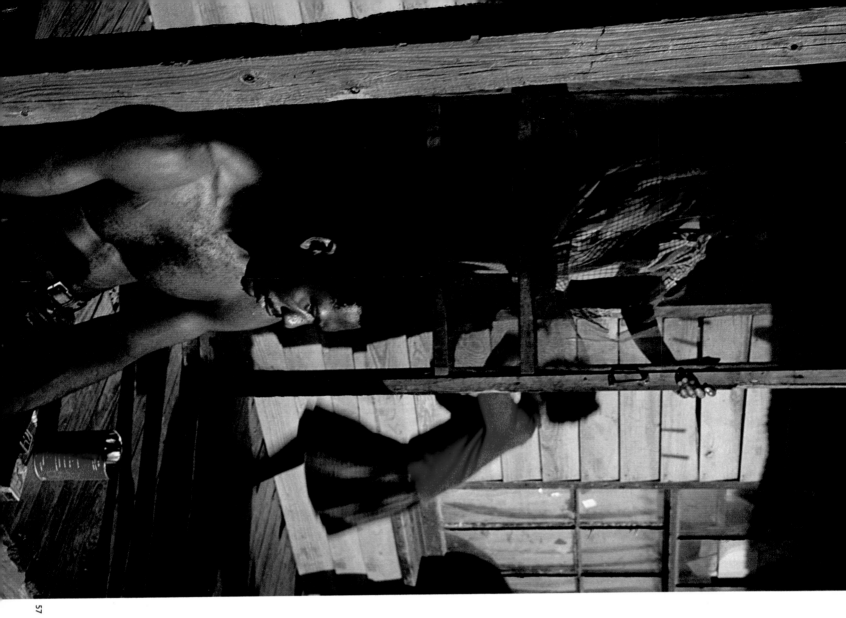

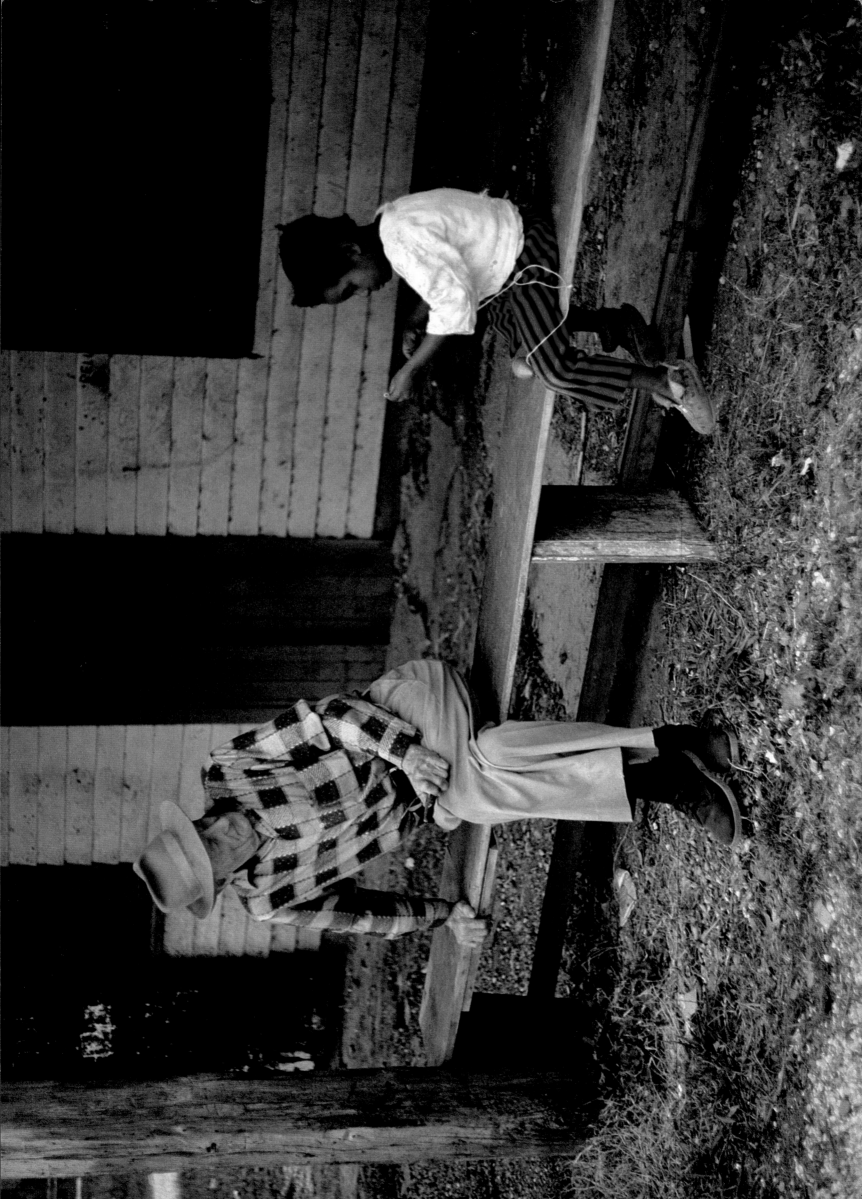

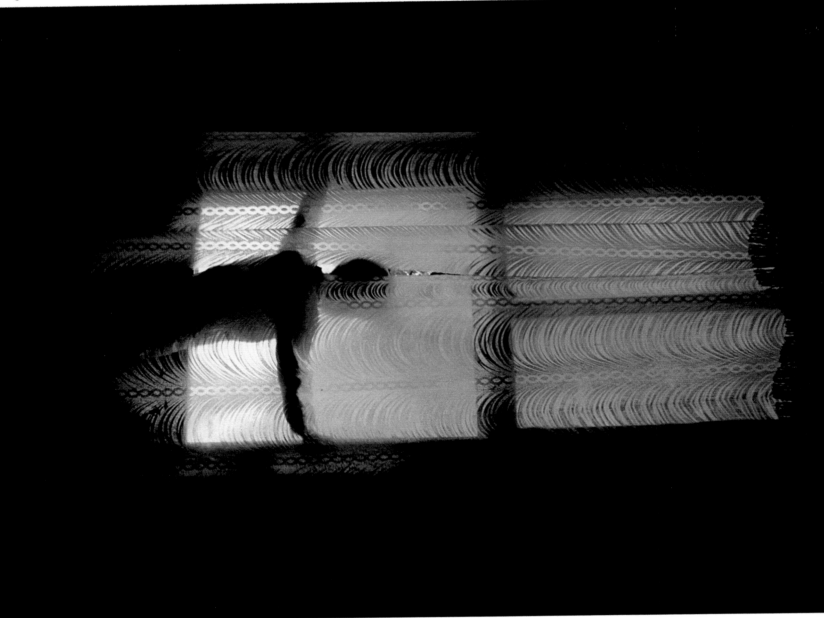

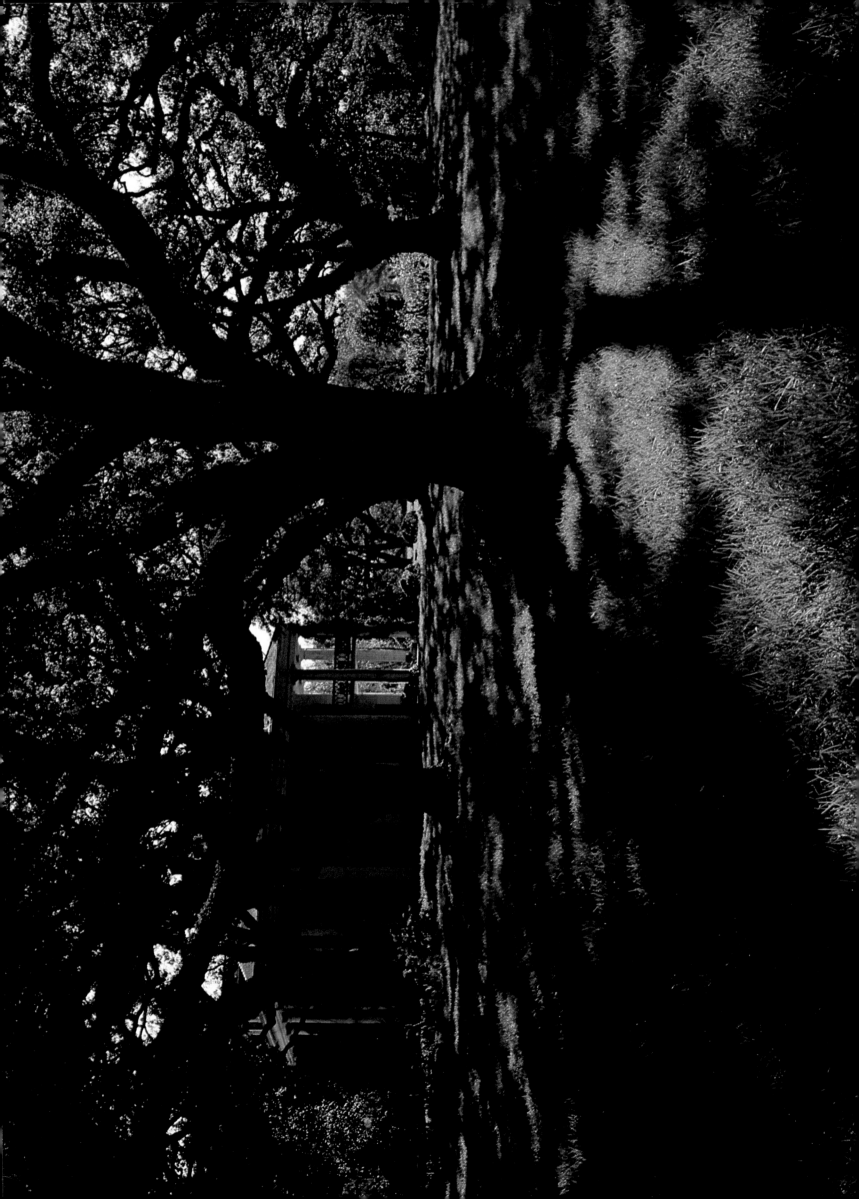

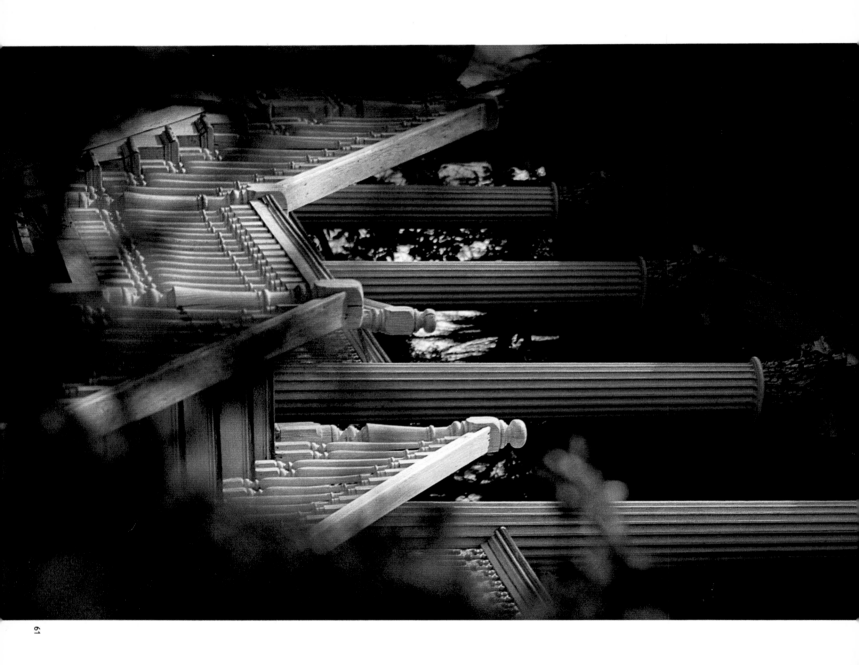

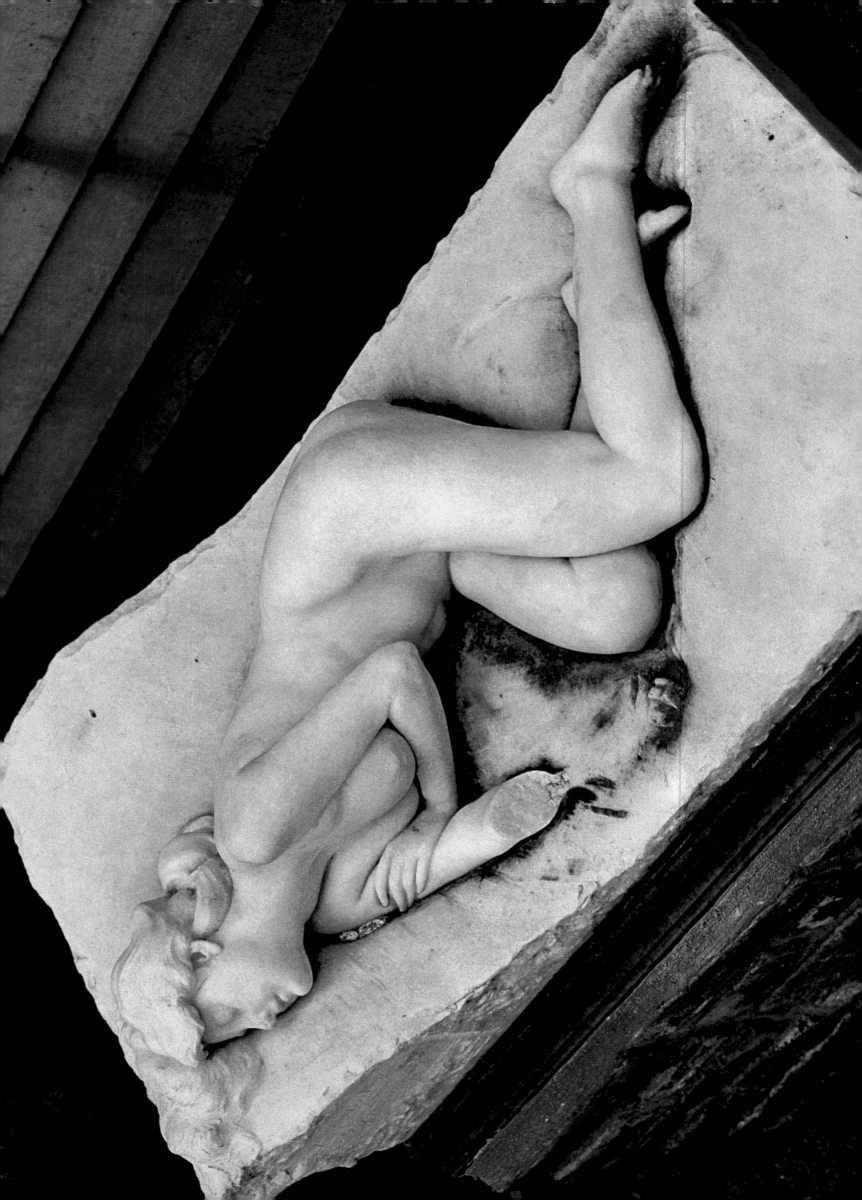

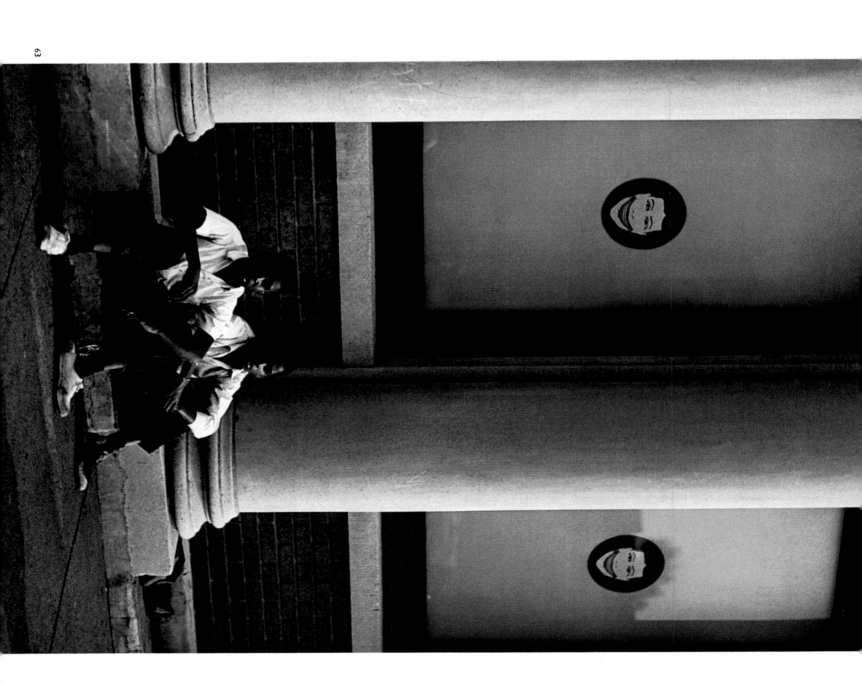

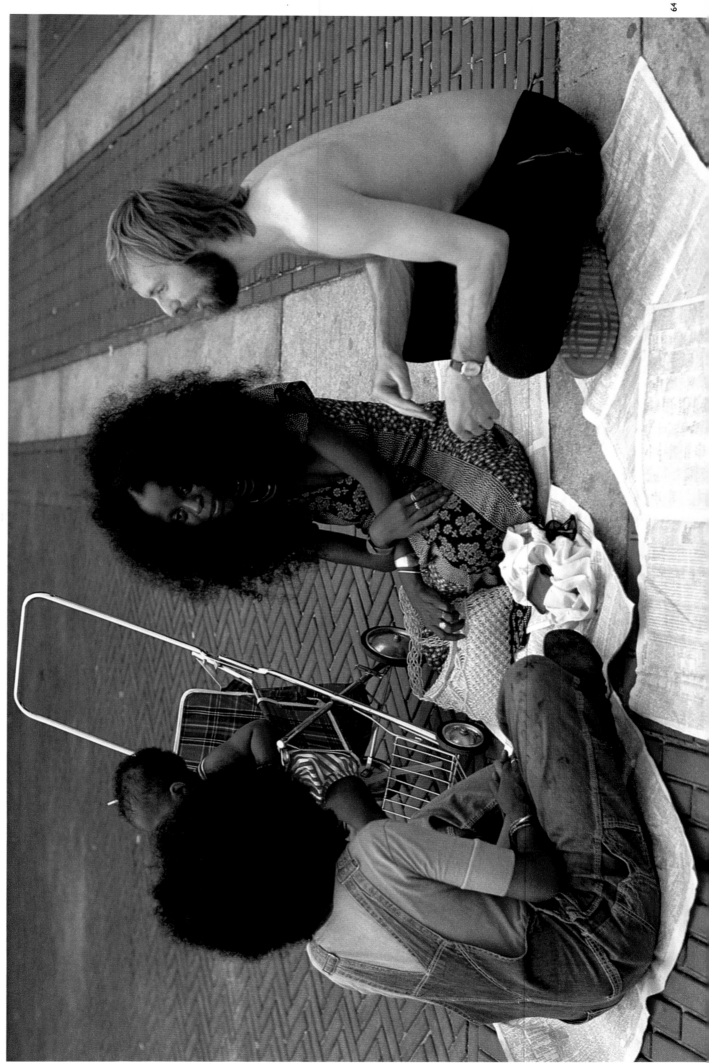

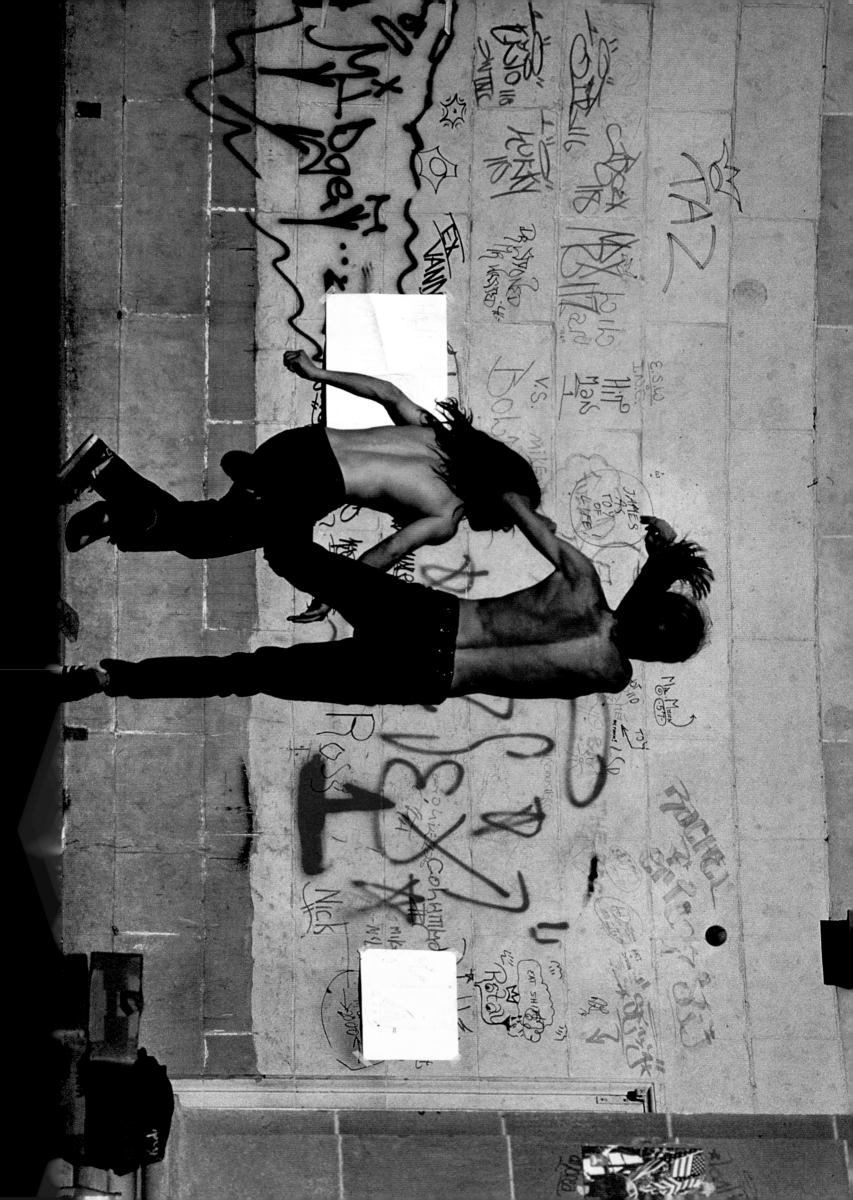

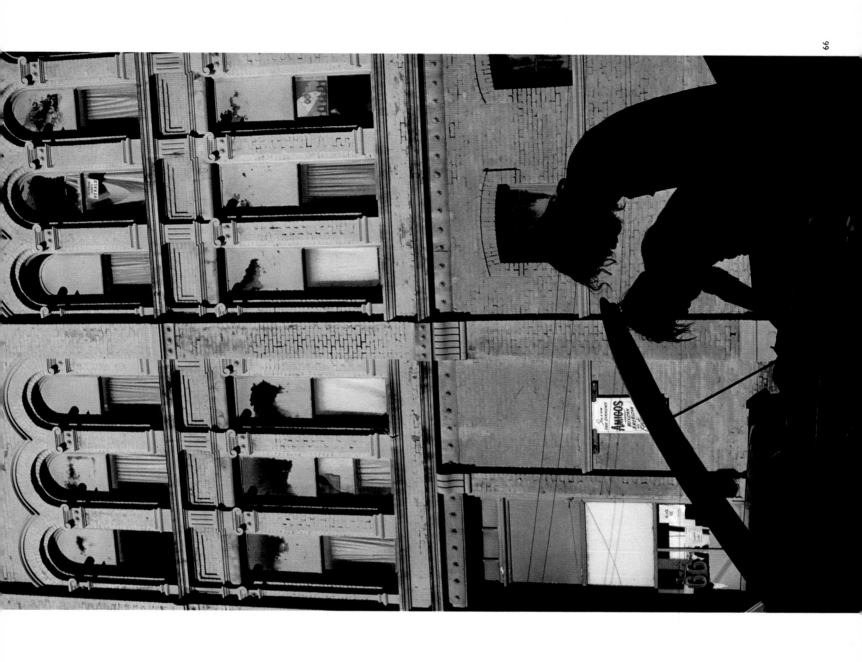

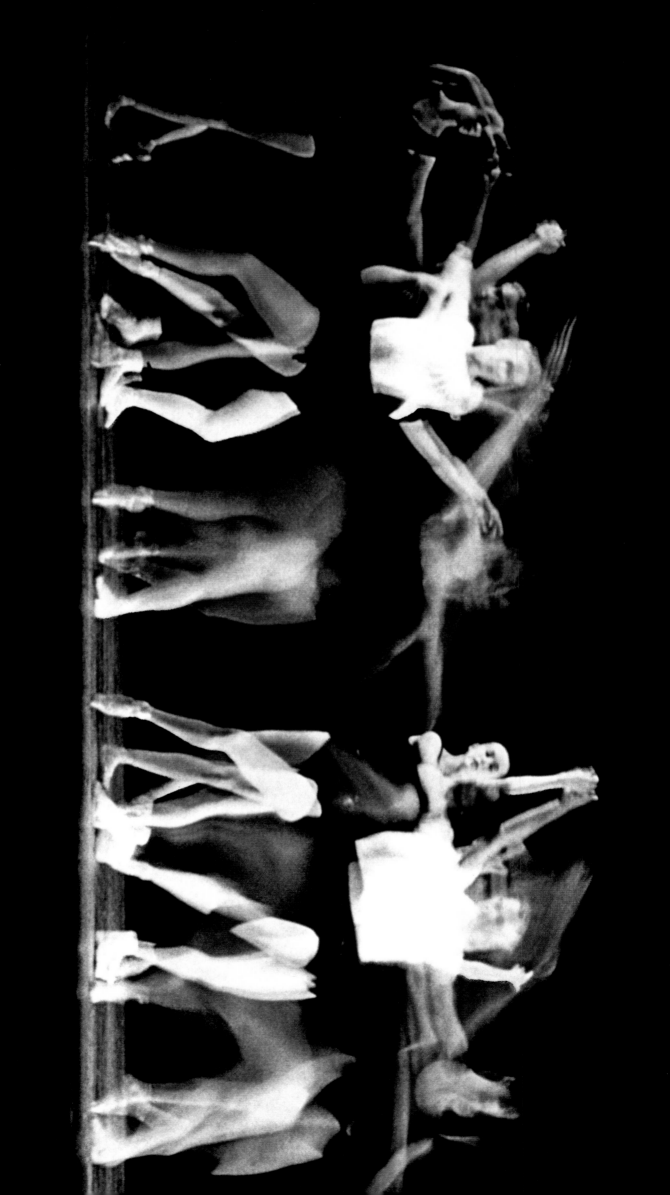

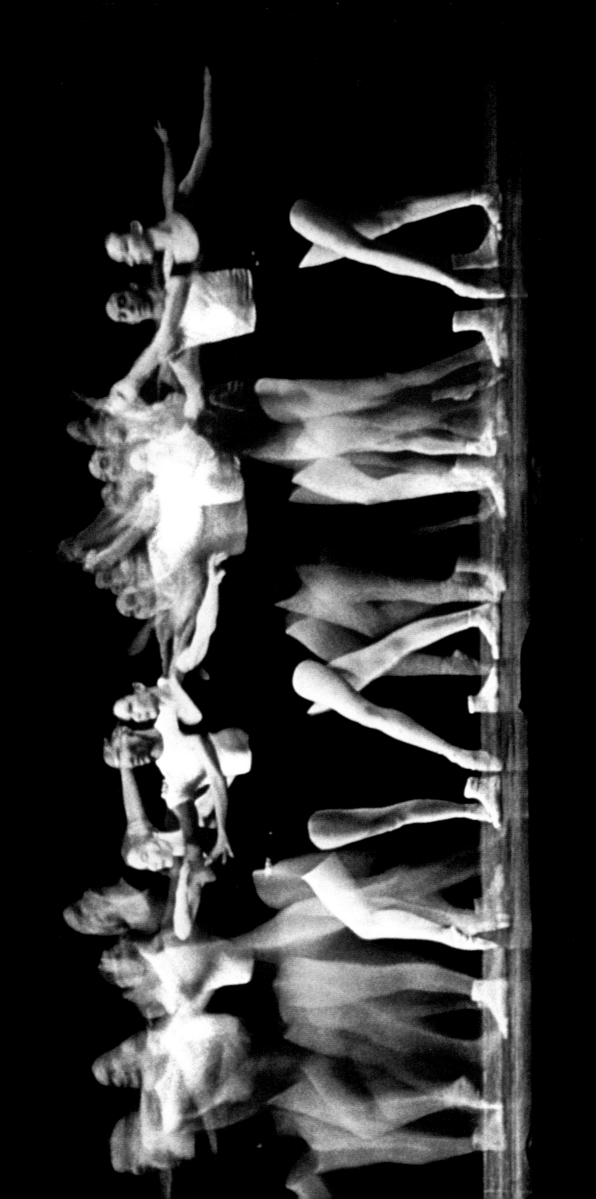

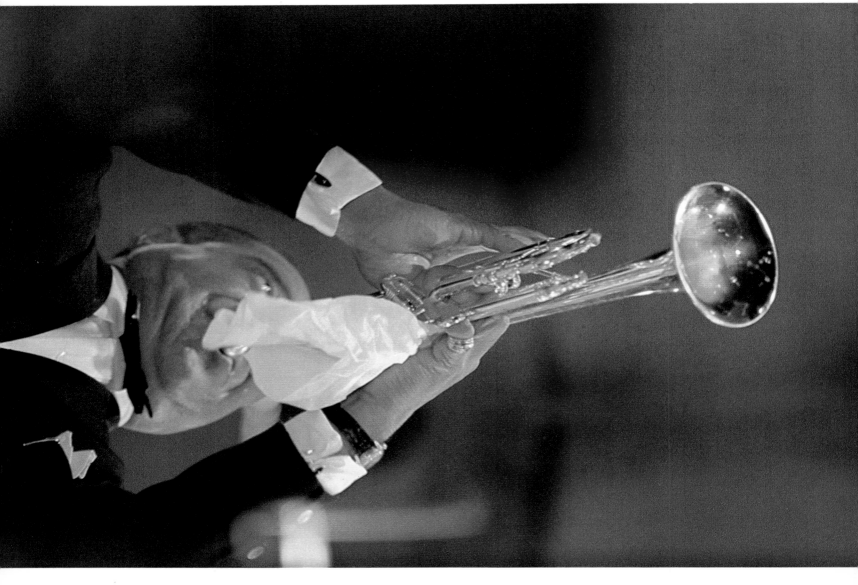

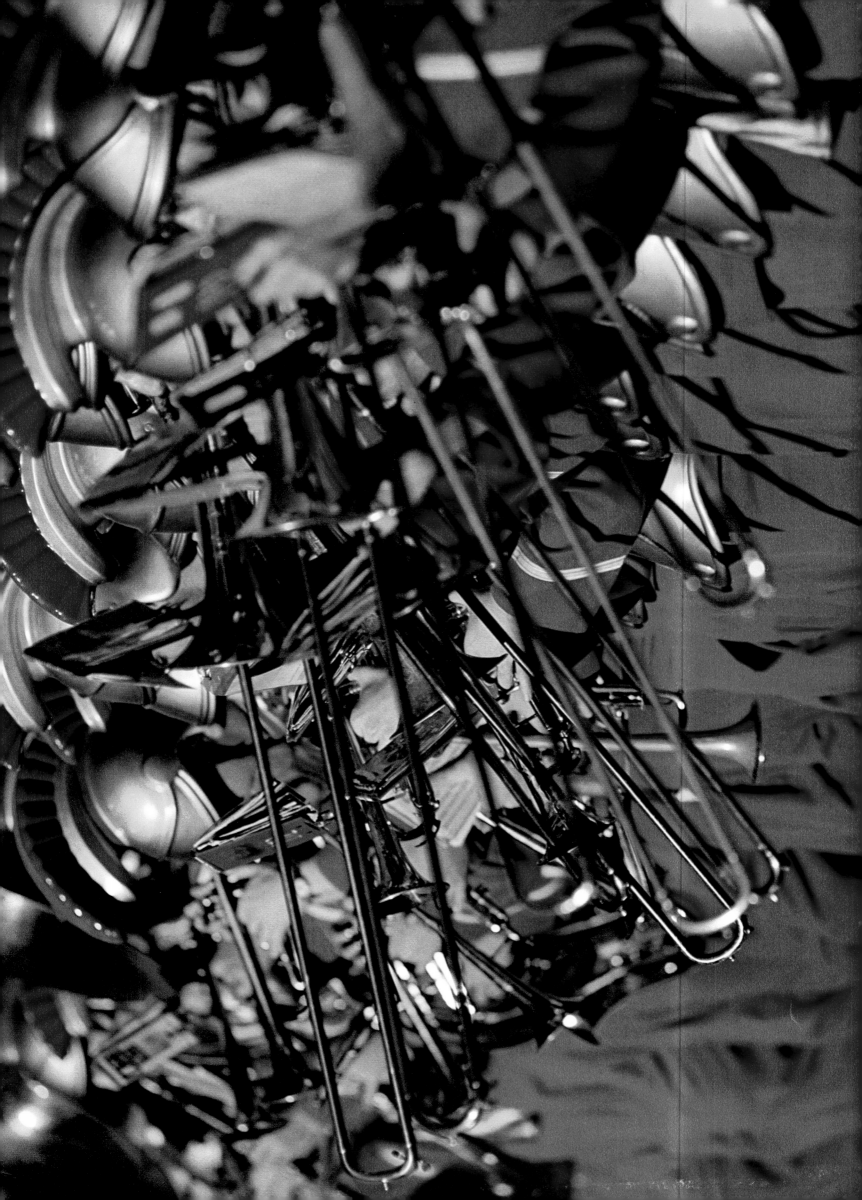

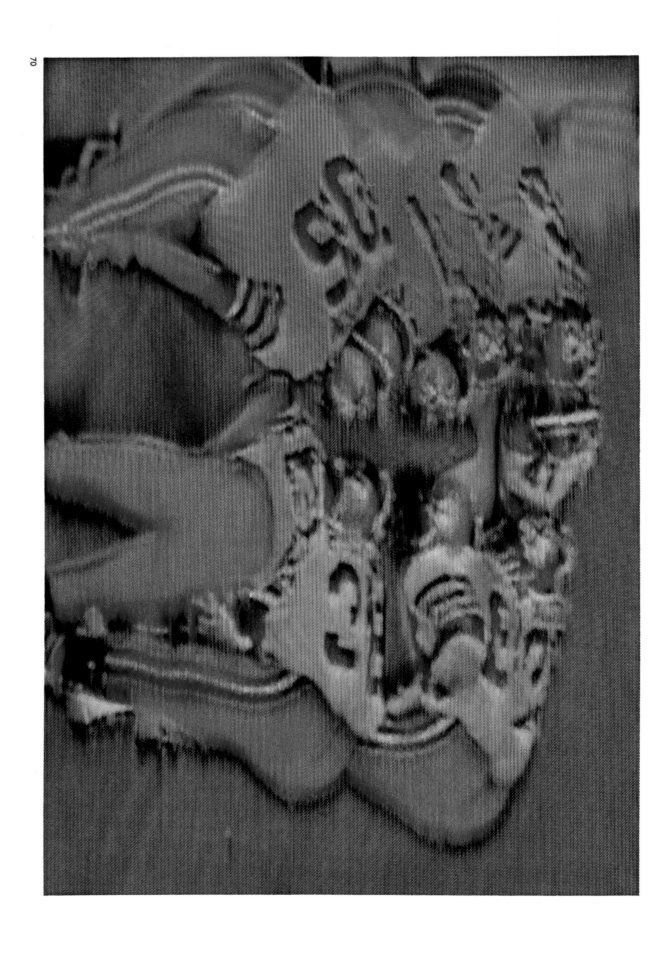

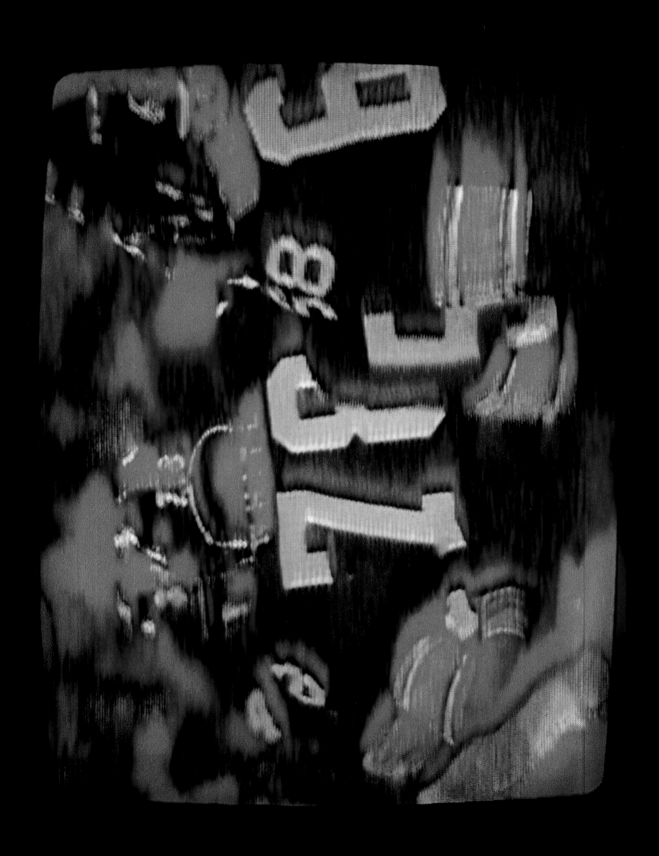

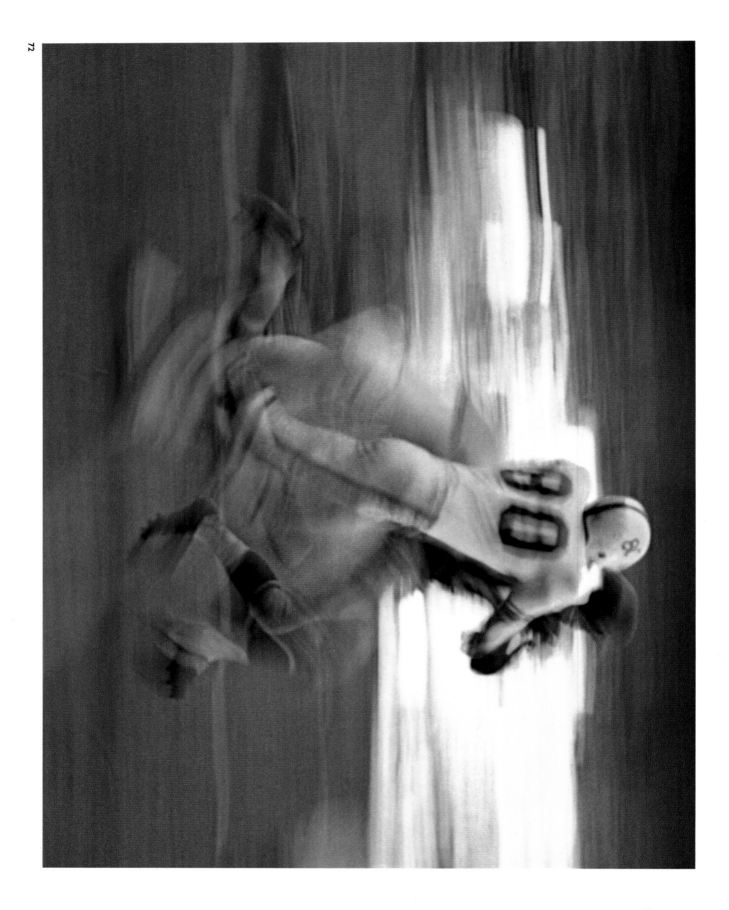

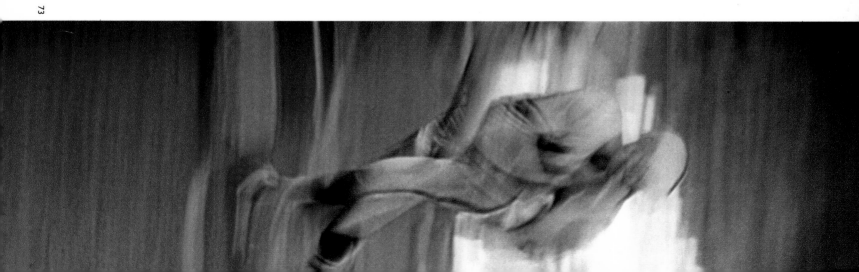

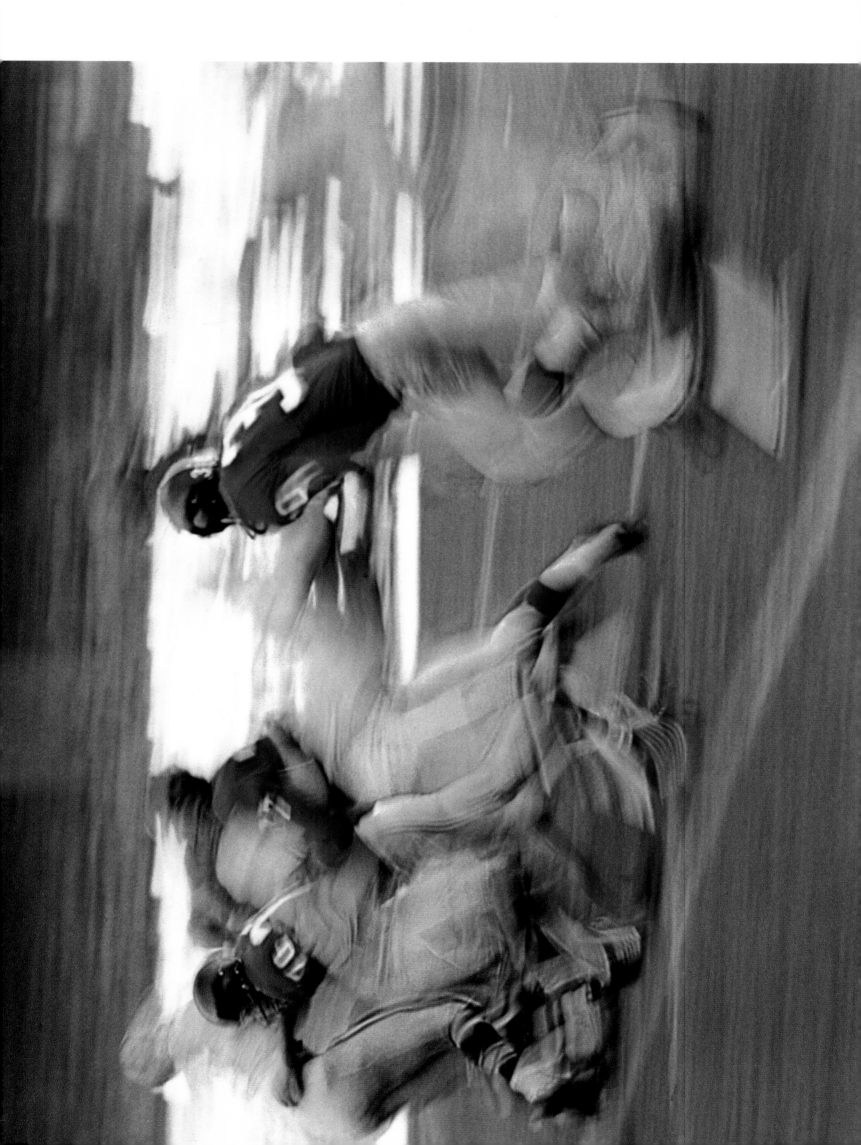

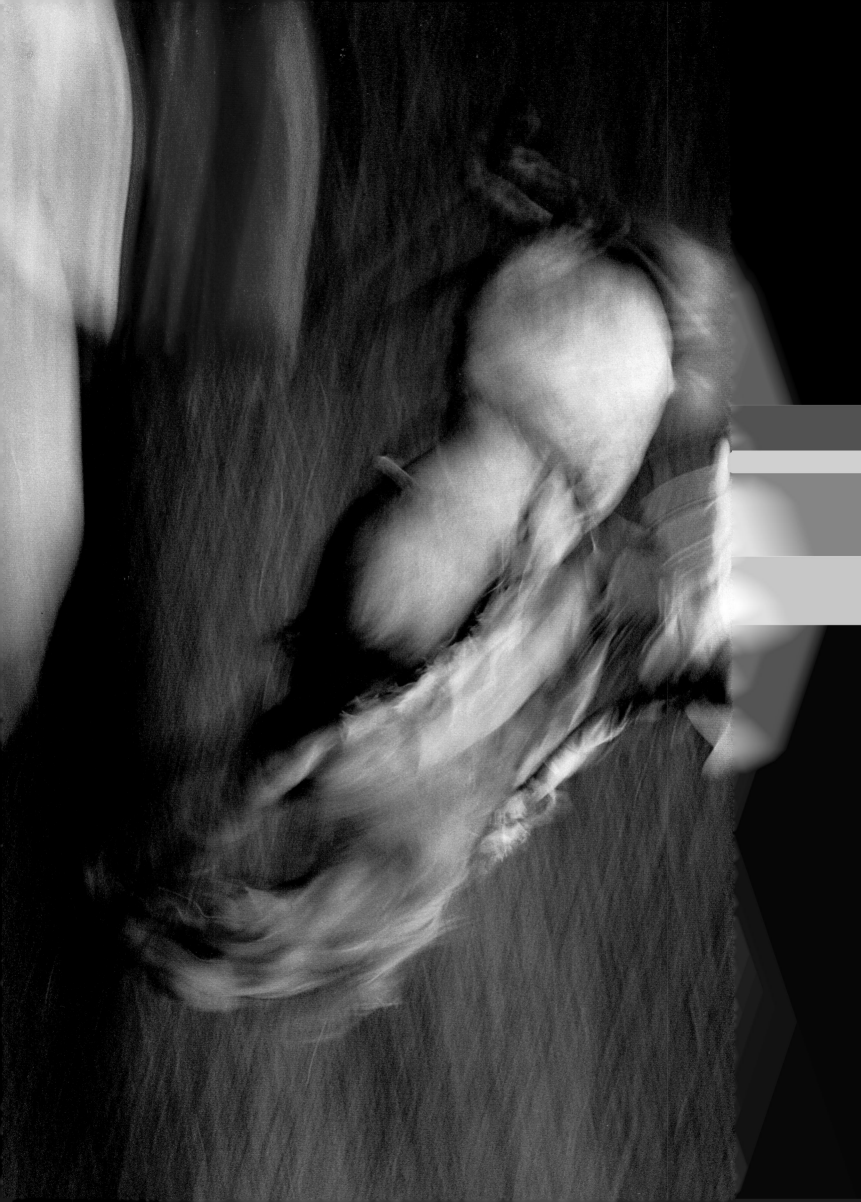

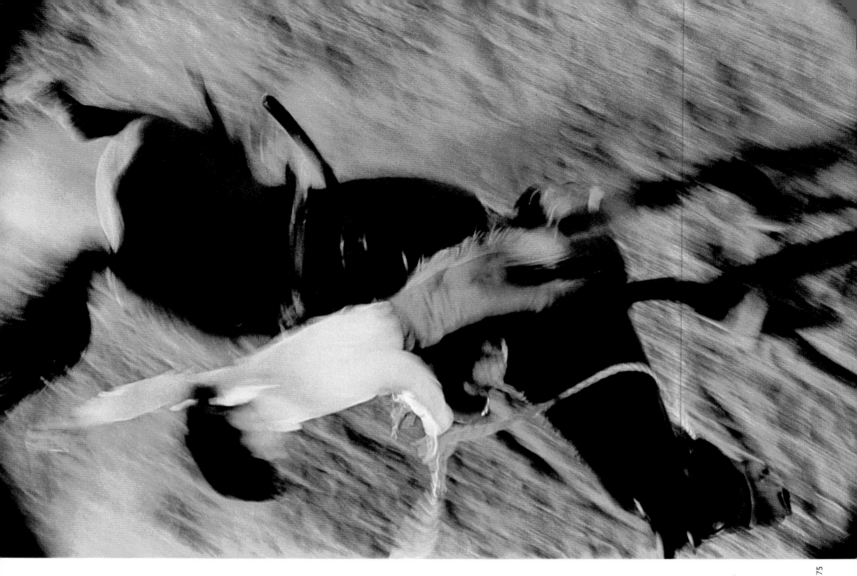

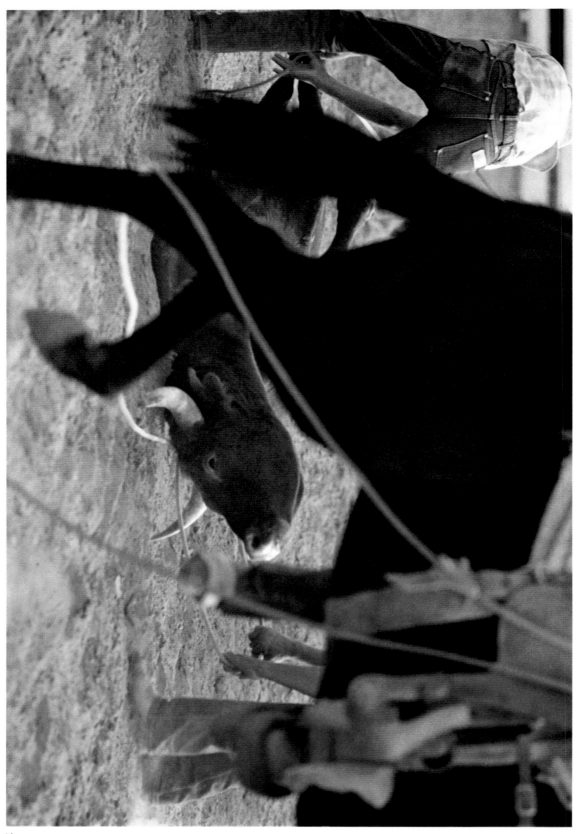

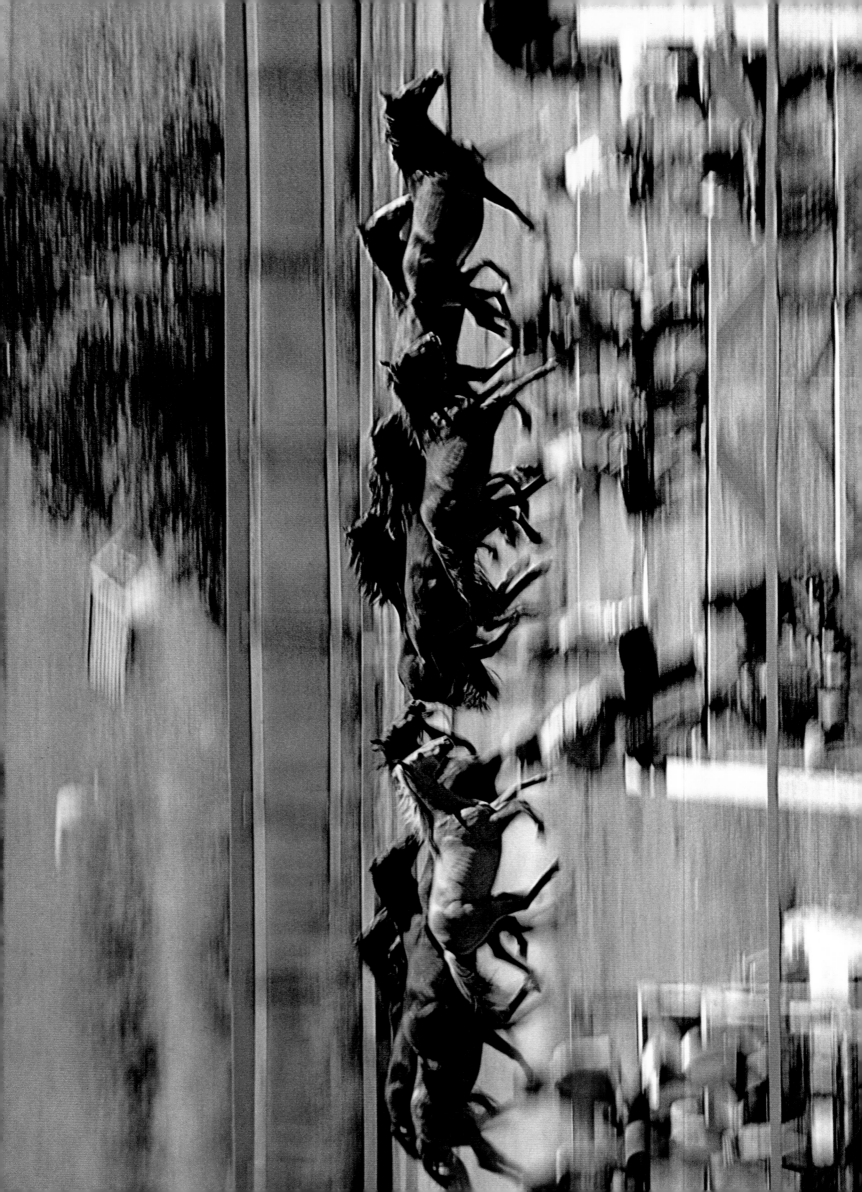

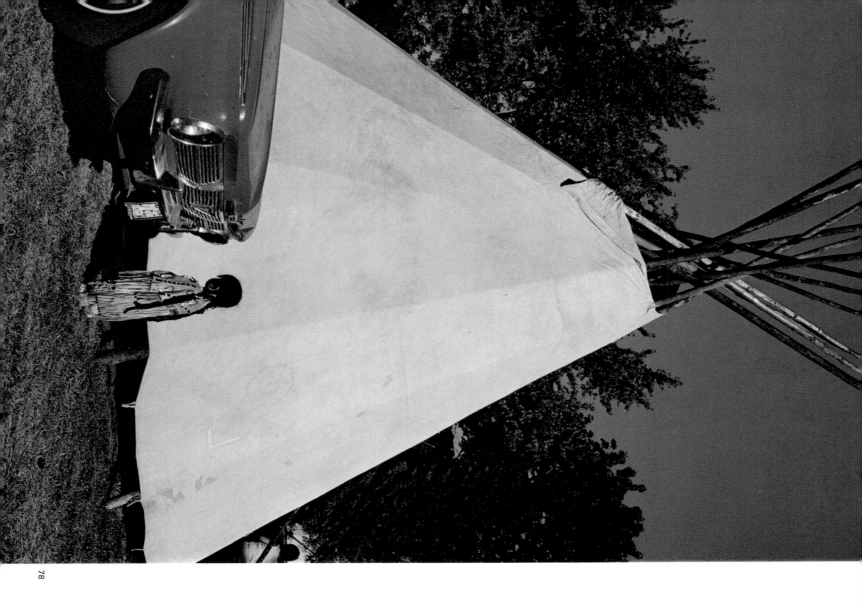

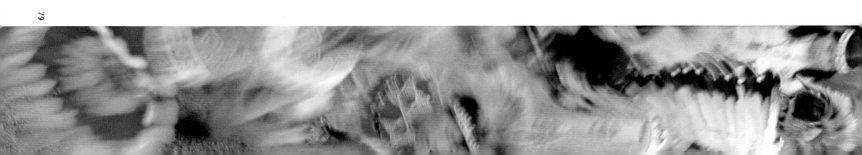

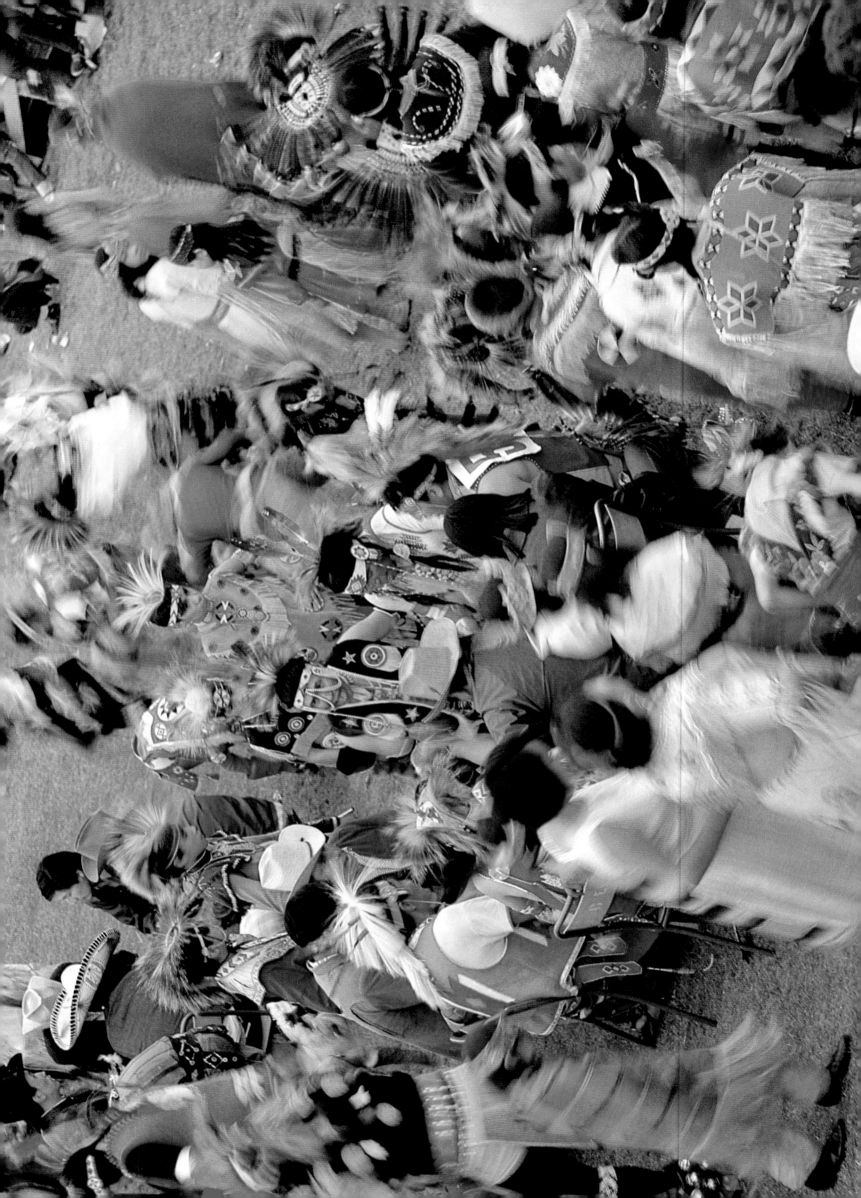

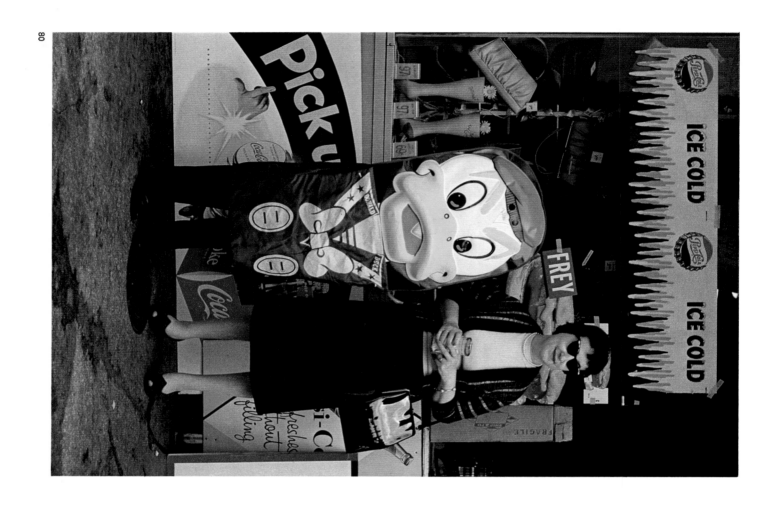

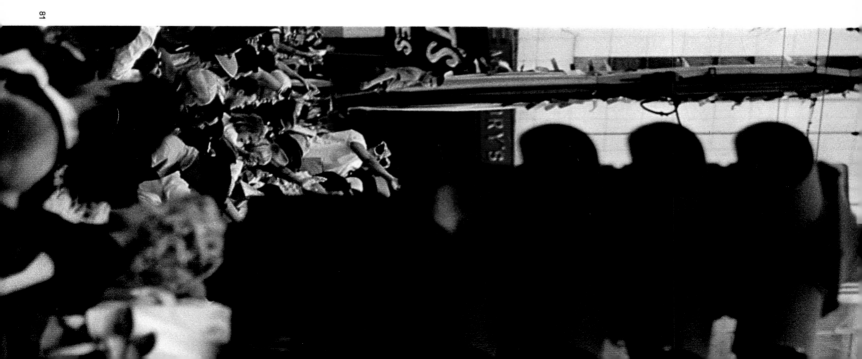

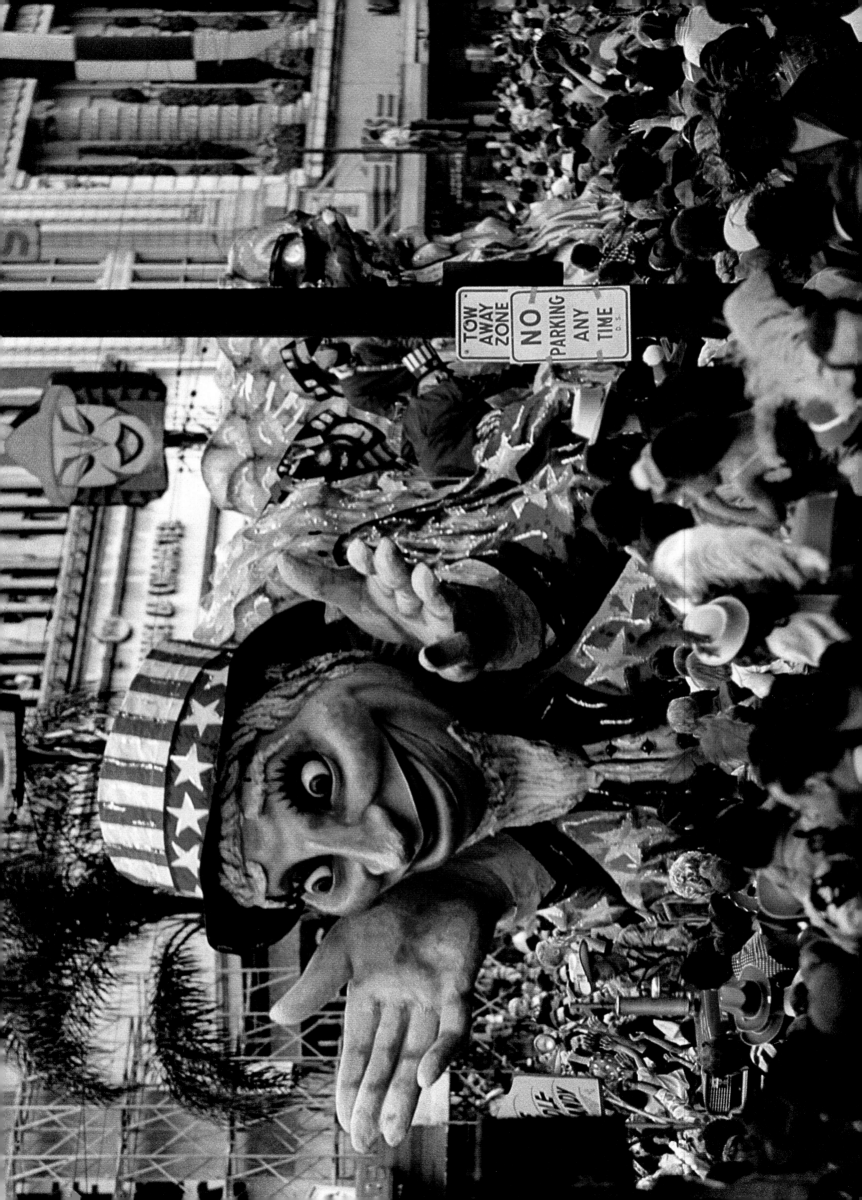

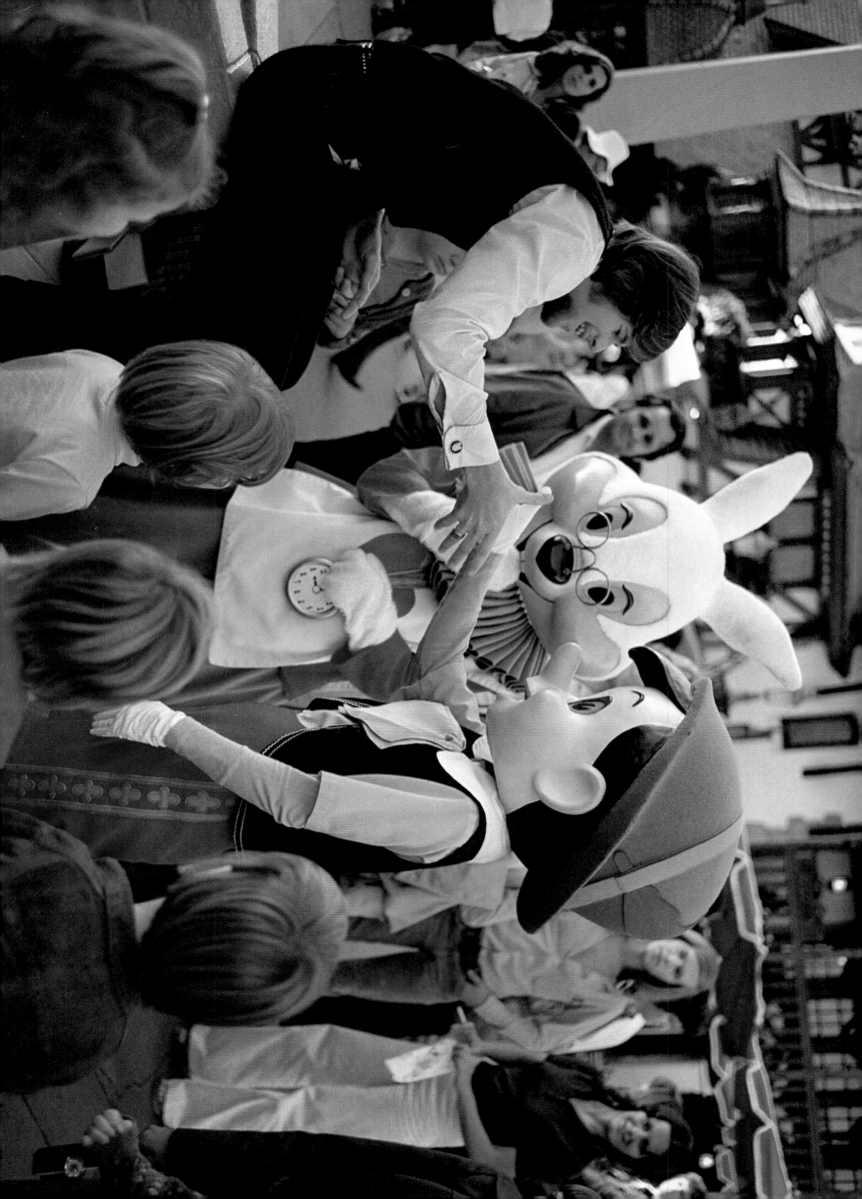

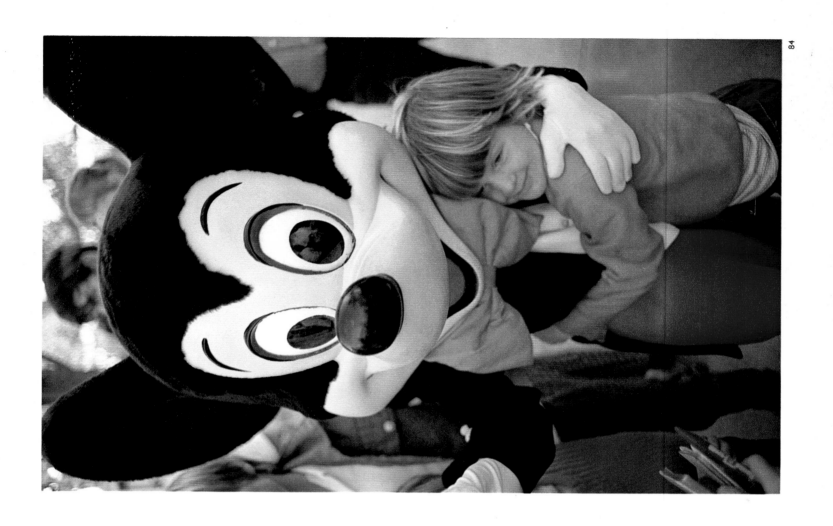

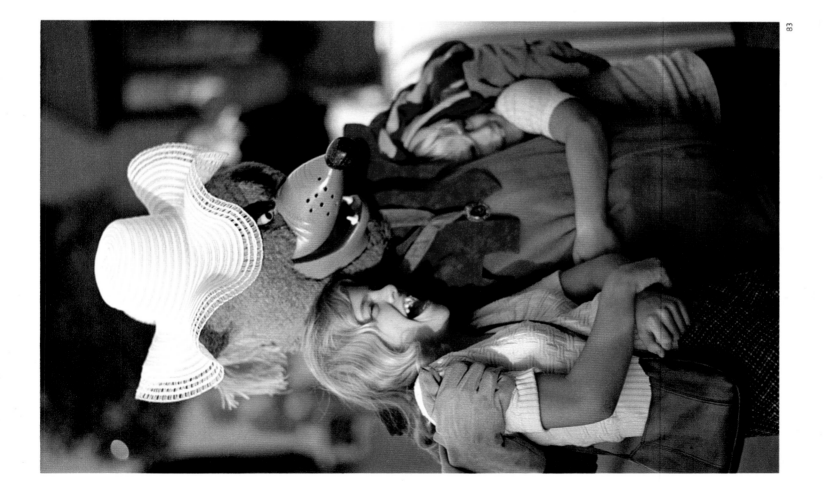

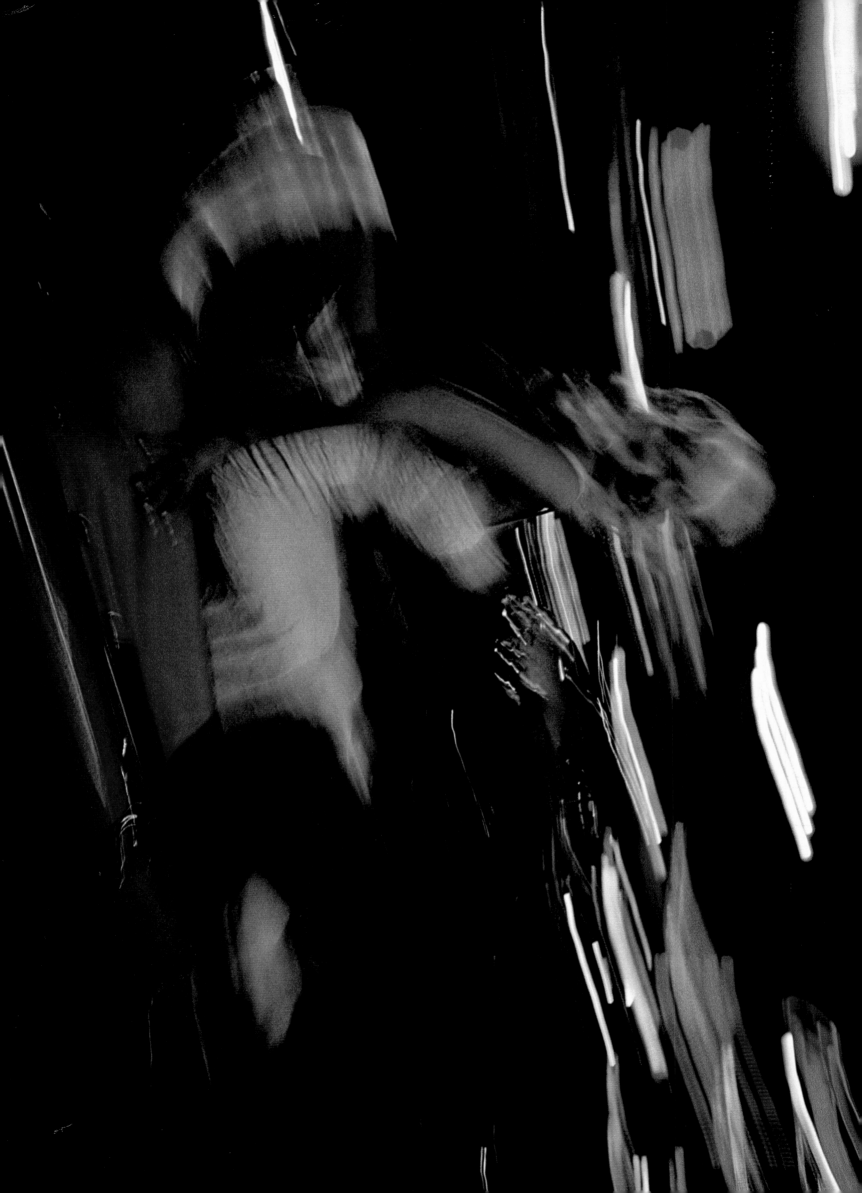

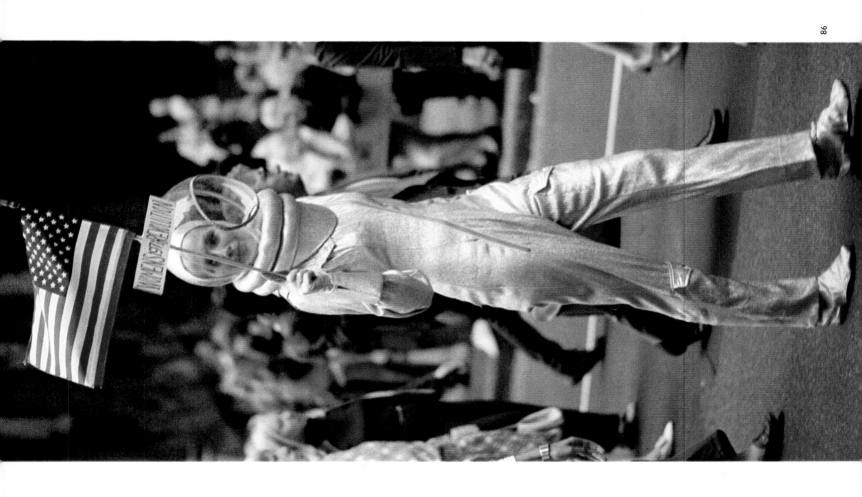

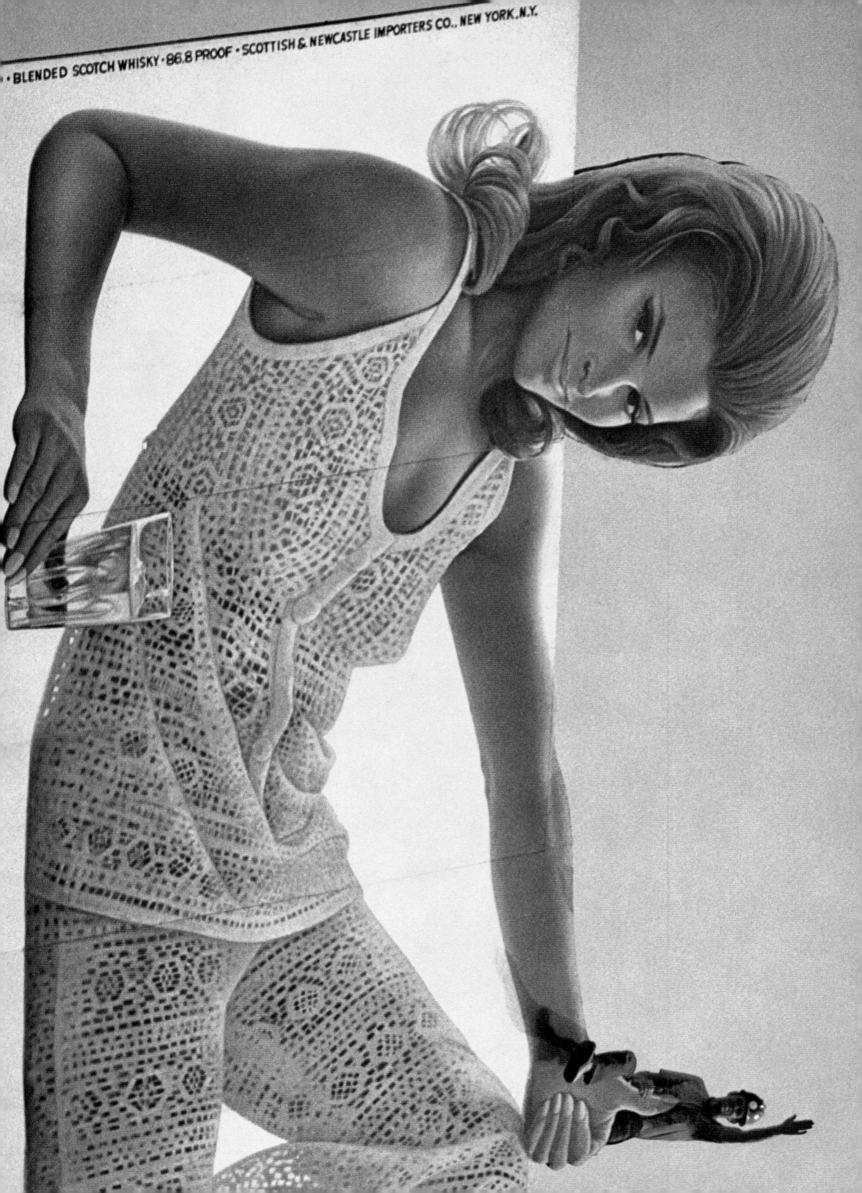

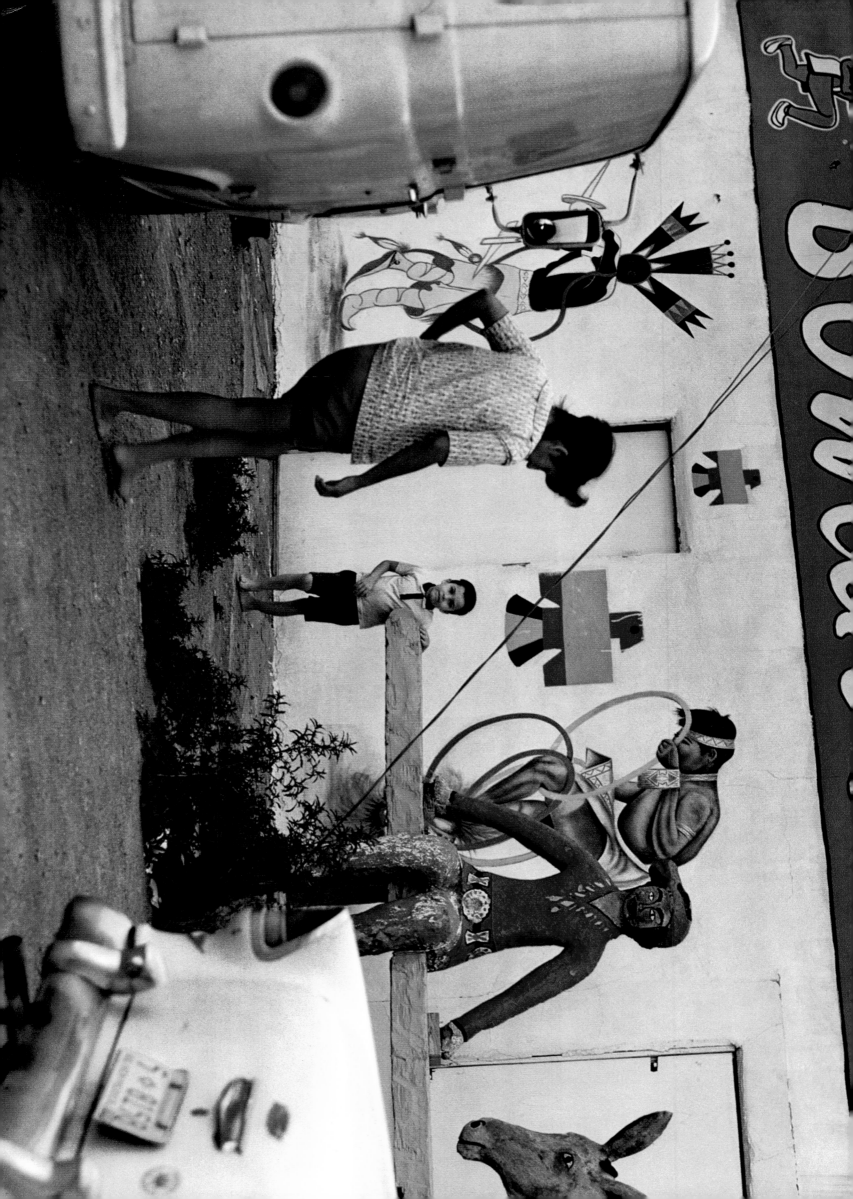

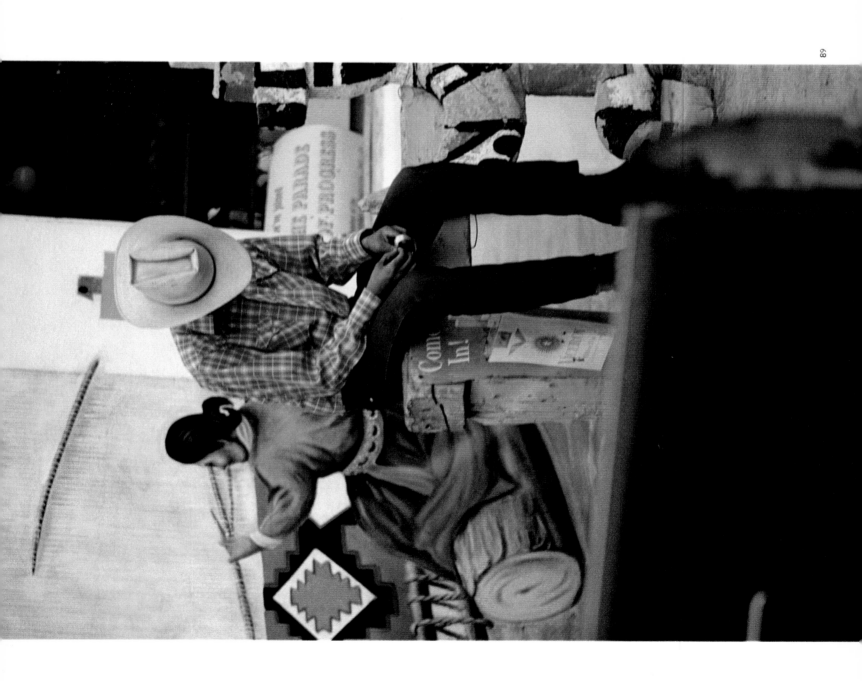

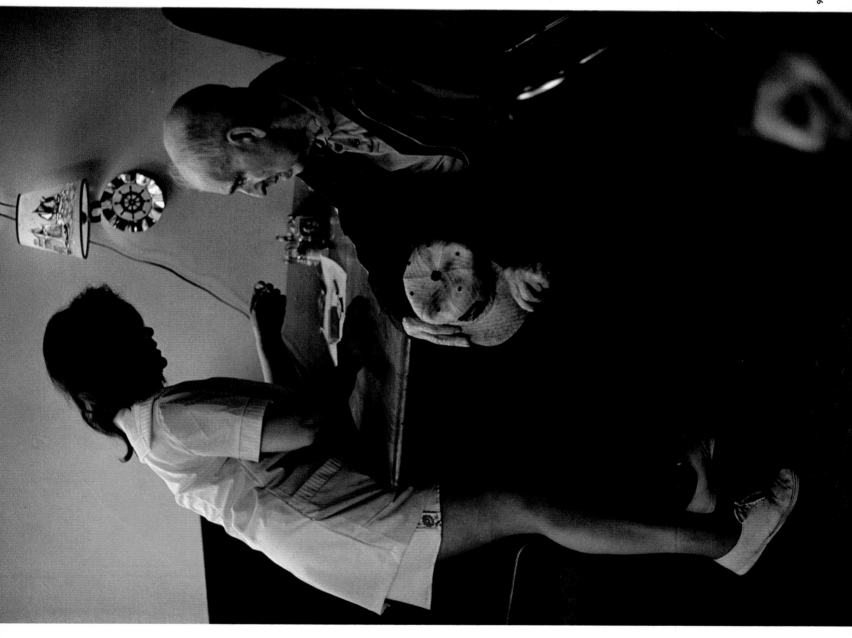

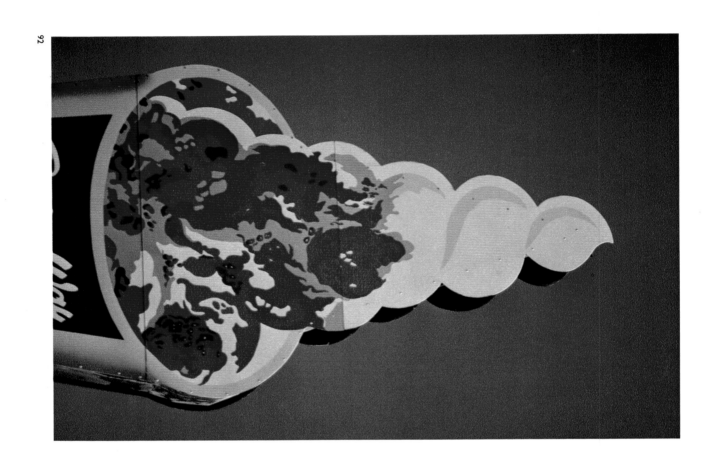

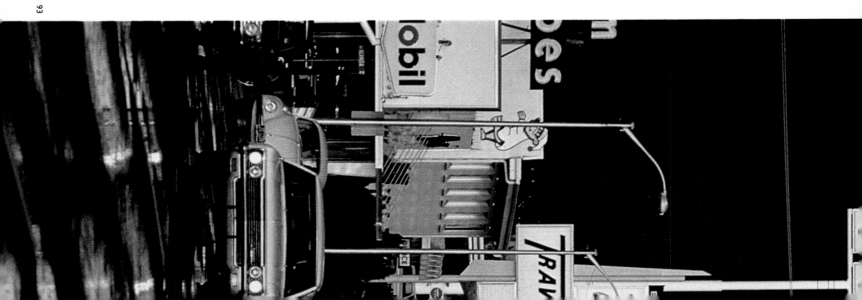

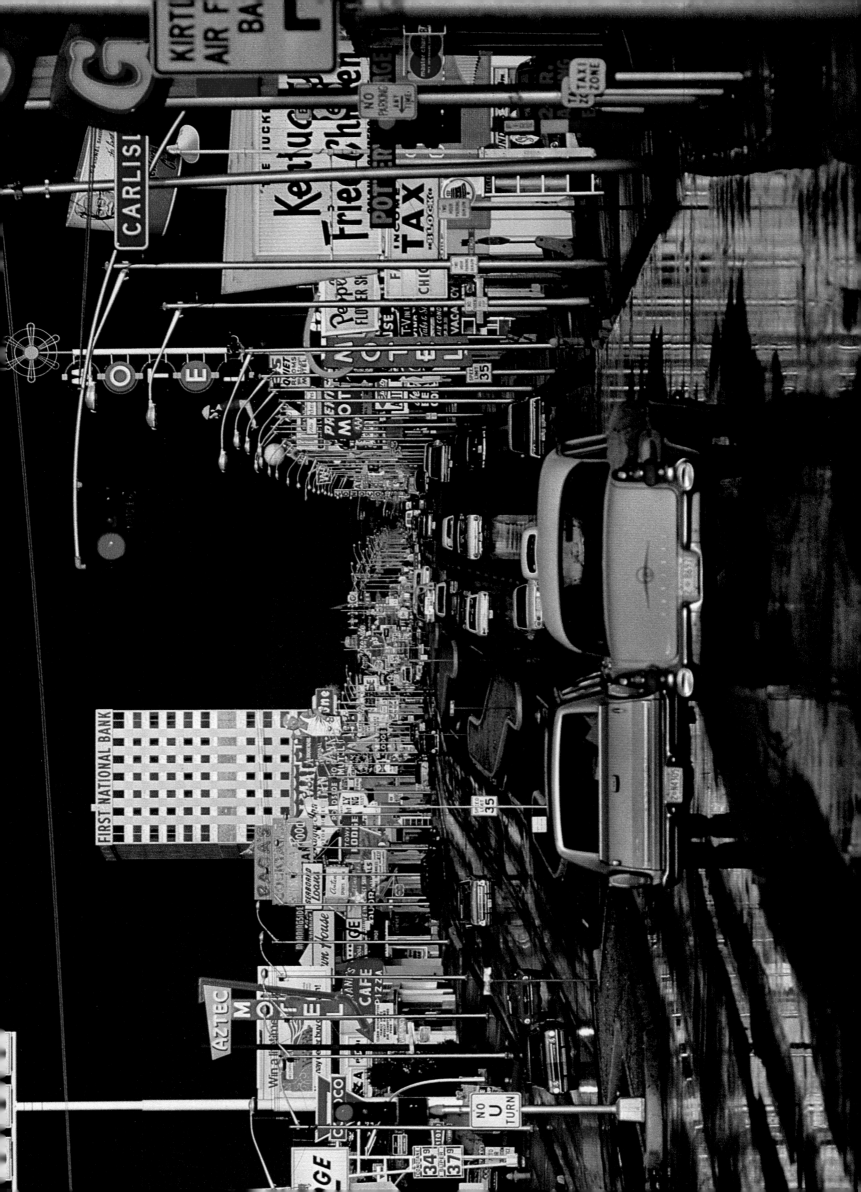

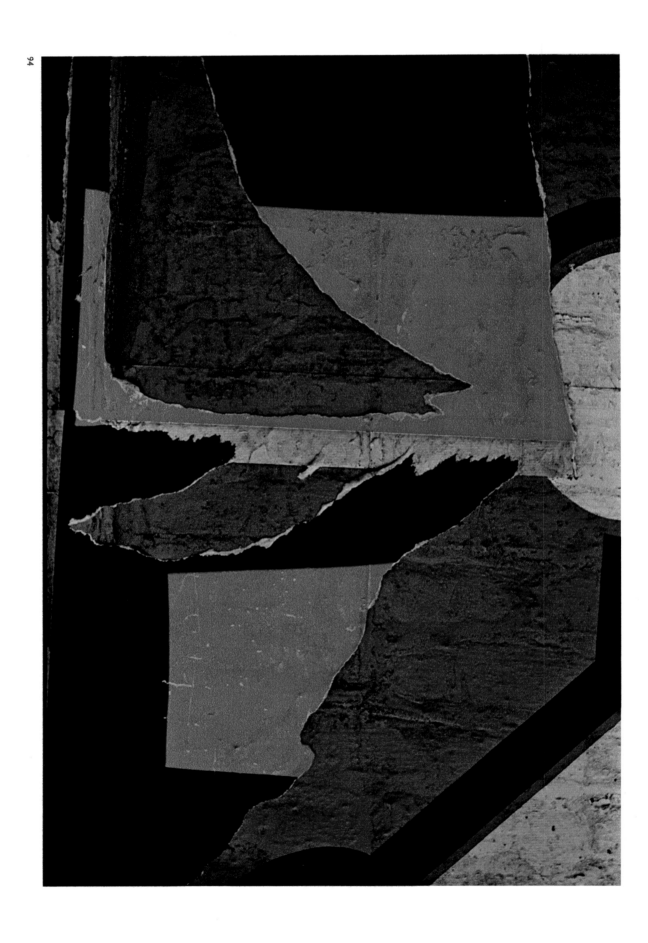

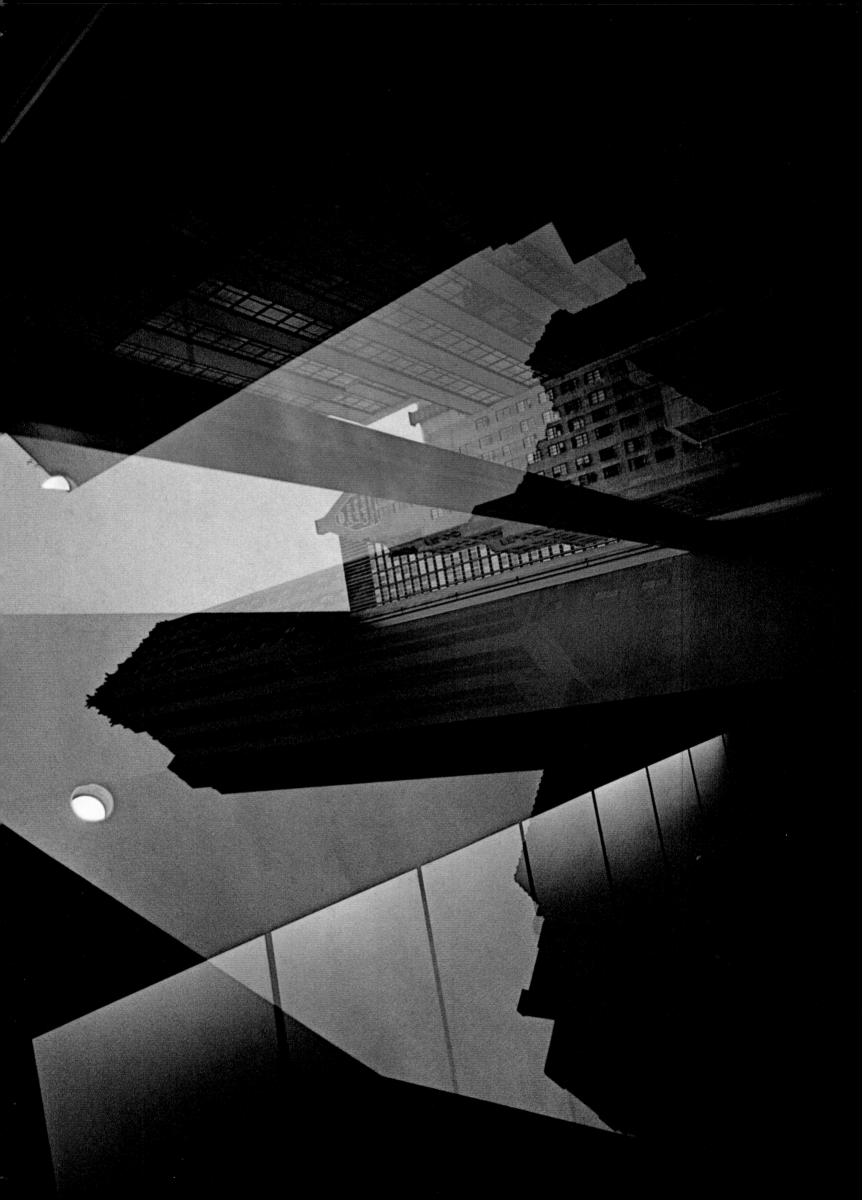

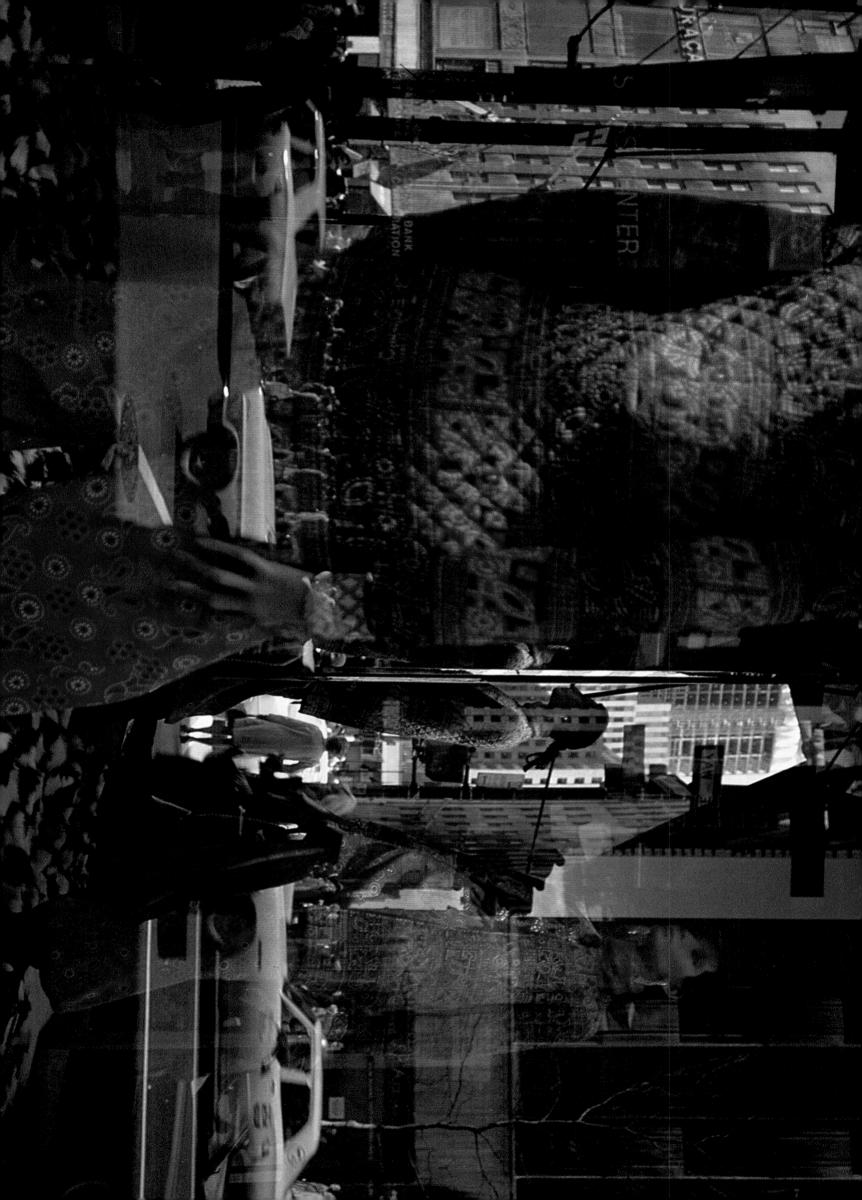

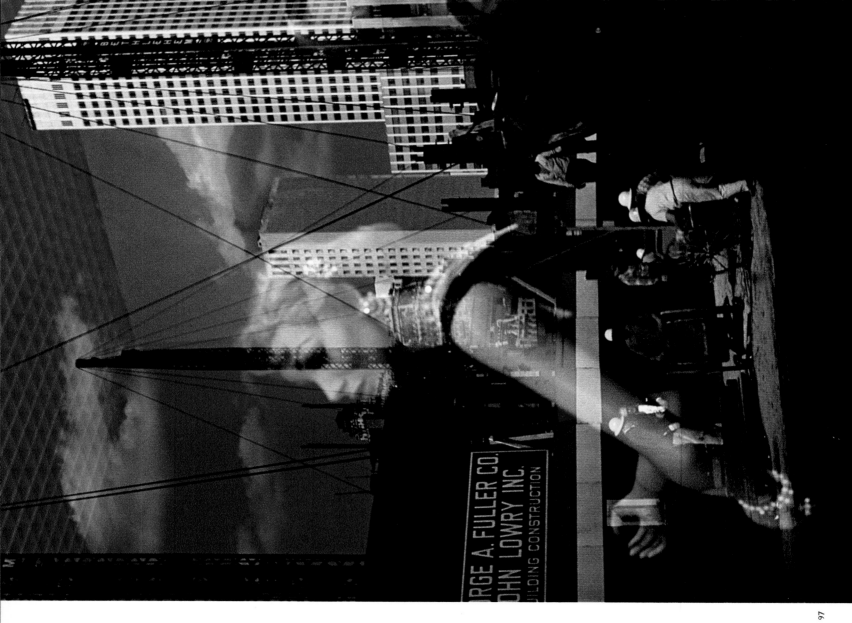

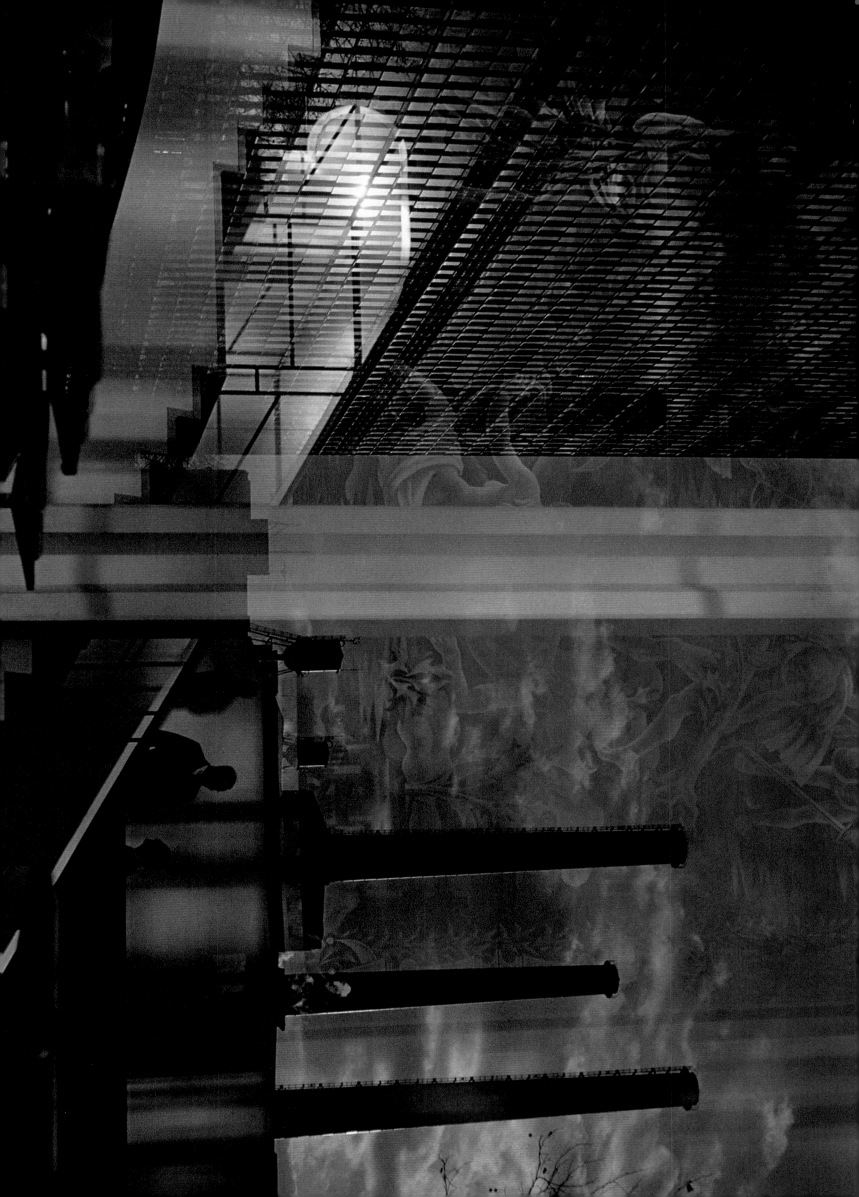

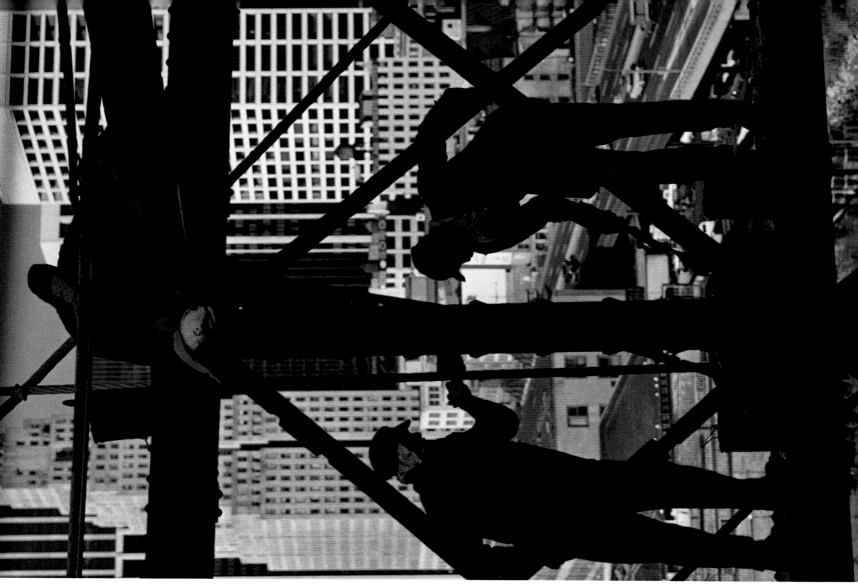

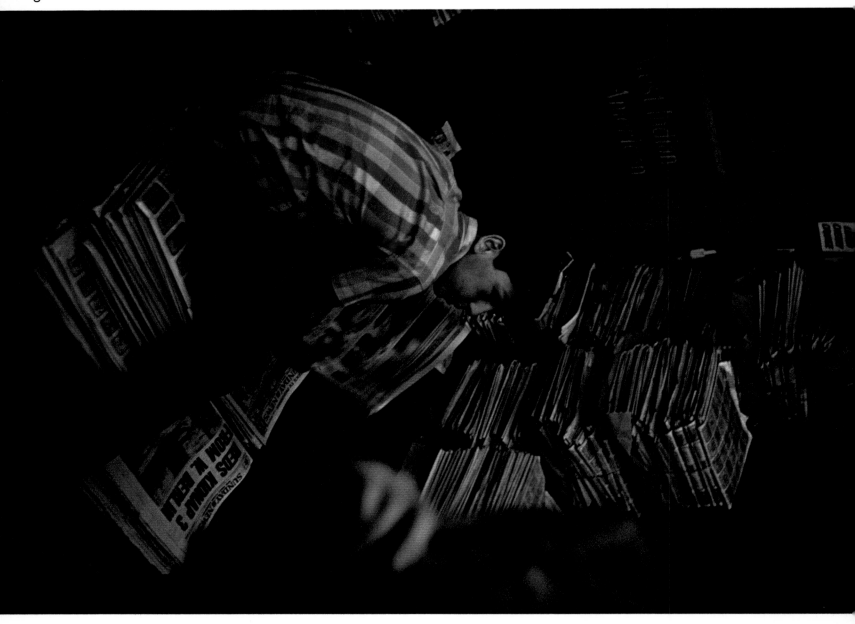

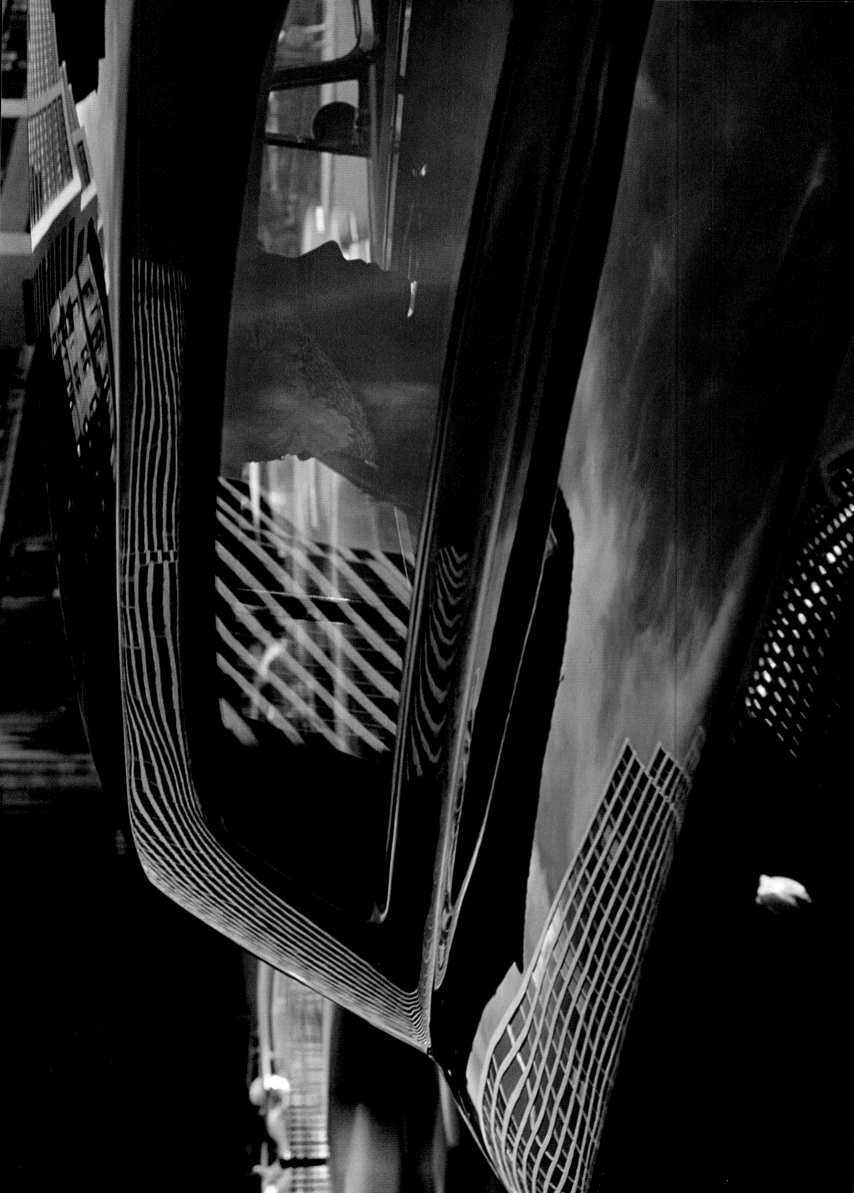

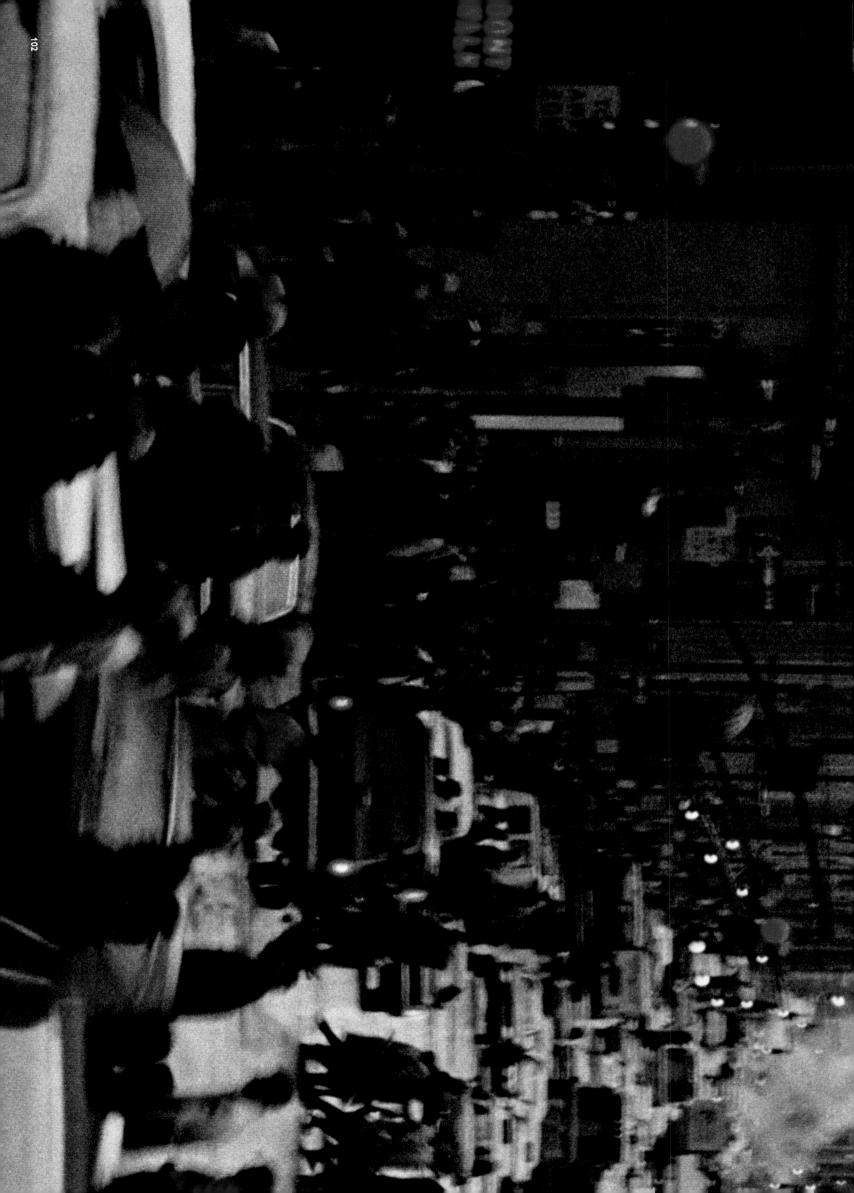

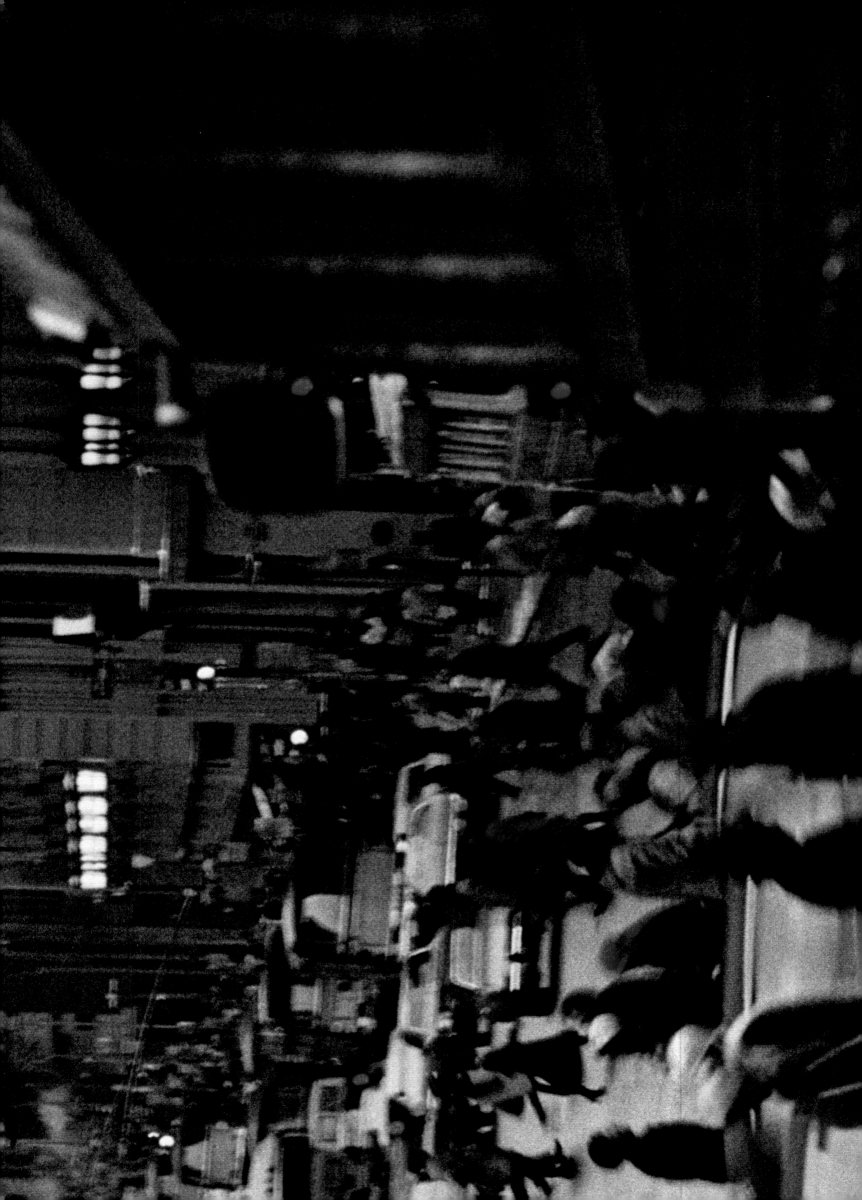

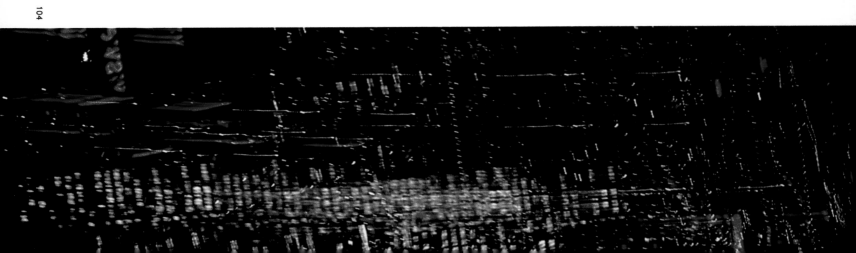

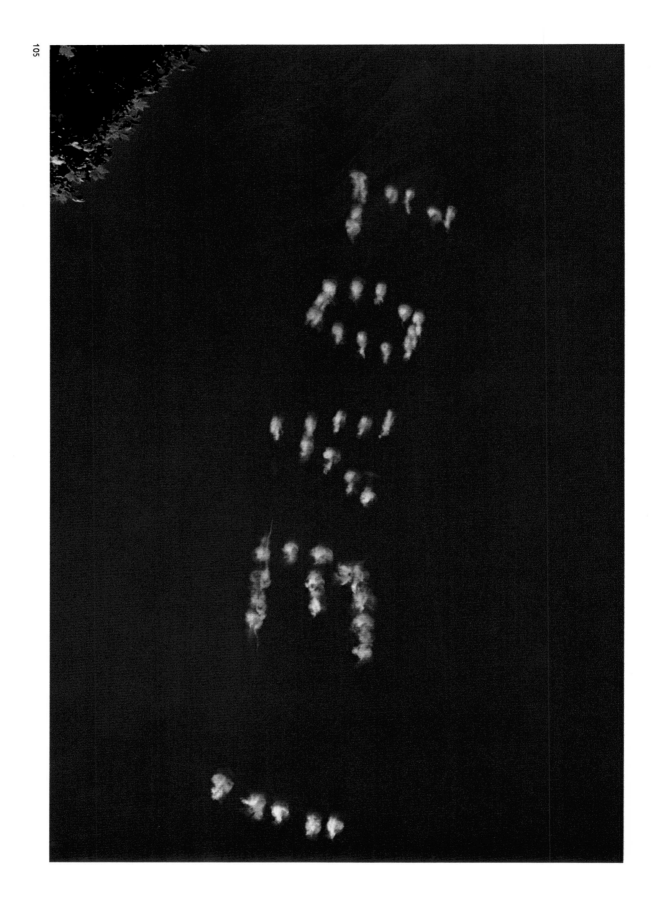

Notes on the Plates

1 *The land before man.* A landscape which today must appear essentially as it did before the arrival of man. The Monument Valley ruins lie in Navajo reservation country, close to the Arizona/Utah border. The "stubs" are eroded remains of former volcanoes.

2 *The Grand Canyon at dawn.* Perhaps the most naturally beautiful and awe-inspiring sight in America: the Grand Canyon, illuminated by the rising sun. Over many millions of years the mighty Colorado River has eaten through the stone, altering the face of the canyon. The earliest geologic changes of this country are nowhere more clearly documented than they are here.

3 & 4 *Indian cliff dwellings.* Close to the river and shadowed from the blazing sun, the canyons were the Indians' first natural habitat. These dwellings, altered by the various inhabitants over the years, were originally part of the first villages established by the Anasazi, ancestors of the Pueblo Indians.

5 & 6 *Petroglyphs and pictographs.* Years ago, I became interested in the cave paintings of Europe and in the significance of those great pictographs painted thousands of years ago. In Utah, Arizona, and New Mexico, such pictographs, as well as petroglyphs incised in the rocks so that signs and images appear in a different tone, are the first evidence of man in America. Here, as in Europe, their symbolic meaning is not completely known, although many theories have been advanced. These petroglyphs are high up on a wall in the Canyon de Chelly. In contrast to the more primitive quality of the petroglyph pictured on the left-hand page, the one on the right, which measures about twenty feet long, seems to document the arrival of the Spaniards with the cross of Christianity and the lance. It was the Spaniards who brought the horse to America. Both the foreigners and the animals must have been terrifying sights for the Indians, who had never seen either before.

7 *Charge!* It is rare to see prairie Indians charge as they used to in the days of the covered wagon. But during the filming of *Little Big Man*, Crow Indians were used in the battle scene of Little Bighorn. Almost everything they wore was authentic tribal costume. Every year the Crow reenact and celebrate the battle of Custer's last stand here; today the battlefield is a national monument in Montana.

8 *Roaming buffalo.* The script of *The Oregon Trail*, filmed on location, called for a herd of buffalo. At the time of the story, pioneers moving West saw millions of these American bison. Today they are rare, but I was able to photograph this group from a covered wagon as the animals were running toward it—not an entirely pleasant sensation, but one which conveyed the feeling the pioneers must have had when they encountered immense herds along the trail.

9, 10 & 11 *Winter in Yellowstone.* Given a chance to choose my own magazine assignment in 1966, I picked the national parks in winter. At that time, the parks were closed to tourists during the winter season. For weeks, guided by game wardens, I traveled on snowshoes through Yellowstone National Park, walking in a vast stillness that brought out a majestic beauty quite different from the overcrowded scenes of summer with their tourists, buses, motorcycles, and cars. The elk is standing in a natural hot spring, where it sometimes goes to take a break from the bitter cold.

12 & 13 *Huddled against the cold.* During the filming of *Little Big Man*, I spent time among the Sarcy Indians. An entire village was asked to live as their ancestors did, and its members were relocated from their permanent homes to buffalo-skin teepees. They were snowed in when I took the photograph on the right, but within a few days they were able to move outside, giving me the opportunity of photographing the reenactment of a scene that must have taken place about

one hundred years ago. The Indians adapted readily to their new roles, sitting around the fire on fur rugs, cooking, and enjoying themselves immensely.

14 *Along an old trail.* During film productions, I usually accompany the so-called second unit of the film crew, which works without actors and tries to convey the epoch and general atmosphere that is to pervade the film. In this picture of an antique covered wagon, taken on an old trail, the horses and riders convey the aura of the Old West.

15 & 16 *The shoot-out—Taming a wild mustang.* The American cowboy is a hero, not only in the West but throughout the world. The "fast draw" was the last man-to-man duel with modern weapons and, when done properly, was executed face-to-face. Though the era of the gunfighter was relatively short-lived, the legend of the heroic gun-slinging cowboy lingers on. This particular photograph was taken during the filming of *The Big Country.* The picture opposite, of a man

breaking in a mustang, was taken during the filming of *The Misfits.* Again, the second unit was filming a herd of wild mustangs which they had been able to round up after days of search and much effort in this arid region.

17 & 18 *Man against nature.* These pictures were taken in 1972, during an attempt to recapture the experience of the first expedition down the Colorado River, led by John Wesley Powell in a wooden dory in 1869. Time-Life Books had asked me to participate in the unique venture. Powell had expected to encounter the legendary—though nonexistent—falls of the Colorado. In the photograph on the right, one of the dories is shooting through the rapids known as Lava Falls, the river's biggest thrill. Even with good oarsmen, the boat has a fifty-fifty chance of capsizing.

19 & 20 *Point Lobos and Big Sur.* Point Lobos, a small state park near the Monterey Peninsula in western California, is a place of pilgrimage for nature lovers

and photographers alike. Edward Weston, the famous photographer, photographed and lived here for many years. I have been greatly inspired by his work and would like to pay tribute to him with two pictures of my own, Point Lobos on the left and Big Sur on the right.

21 & 22 *Autumn colors, east and west.* Autumn is the reflective season. In eastern America and in the West, it is a time when landscapes, vivid reds and yellows, turn to sadder brown and gold. On the right-hand page is a church in a peaceful golden setting that could be nowhere else in the world but New England. On the left is the Canyon de Chelly in Arizona, over two thousand miles distant. The canyon is still intact and populated by Indians whose ancestors have lived there for many hundreds of years. It has witnessed the most brutal fighting; it has also experienced the peaceful rural living of the Navajos.

23 & 24 *Which way shall we go?* The crisscrossing trails on the left-hand page remind me of unmarked destinations and the choice of directions which the first settlers must have encountered. Their decision sometimes proved favorable and at other times led to hardship. This picture was taken in early winter in Montana, miles away from the site of the old wooden road sign in New England. "Which way shall we go?" is most often expressed best with one's hands.

25 & 26 *The gentle people.* In the summer of 1971 The Art Institute of Kalamazoo, Michigan, invited me to give a lecture on color photography. In exchange for this service, the head of the Institute took me to the Amish country of Orange County, where, as in Pennsylvania's Lancaster County, one can visit the weekly market and find living vestiges of the past. Members of the sect arrive in their stark little black wagons, the only bit of color forced upon them a bright red and orange sign required for slow-moving vehicles. The couple framed by the mirror and surrounded by contemporary objects and fashions are

a reflection of another era. The Amish people, however, do not give an impression of being behind the times; they sustain a life style of elemental grace that exemplifies what the new generation seeks. Here is a man who did not need to learn ecology, he actively lives it.

27 & 28 *Pals.* There is a certain toughness, combined with a certain tenderness, in American kids. They relate to their pets—dogs, cats, or even horses—with affection and humanity. They become their pals. This relationship has become a classic theme in much of American literature, and is expressed particularly well in stories of Tom Sawyer, Rin Tin Tin, and, of course, Lassie.

29, 30, 31 & 32 *Patriotism north and south.* Fife and drum corps perform in many New England states, as in this particular Fife and Drum Festival—one of Connecticut's annual events. As participants and spectators intermingle, the resulting sound has as distinct an Ameri-

can flavor as the spectacle itself. Patriotic sentiments are aroused as are images of pre-Revolutionary and Revolutionary days. In photograph number 29, everything came together: the oxen of the Pilgrims, the modern missiles, the cannons of the Revolution. The picture seems to juxtapose strangely well with the Southern Spirit on the opposite page: a view taken through the window of a liquor shop in Louisiana.

33 & 34 *The motor vehicle comes of age.* The Model T Ford is a symbol of early American mass production. In the 1960s, when *Life* assigned me to illustrate photographically James Agee's story *A Death in the Family*, I drove through many parts of Tennessee in this remarkable auto—capturing both the mood and atmosphere as Agee had. I enjoyed its feeling of openness and the strange grip its wheels had on the old-fashioned back roads.

35 & 36 *Puritan white.* The whiteness of New England befits the Puritan character. White paint makes things

symbolically more pure than they are in their natural color. The combination of white highway line, road sign, white wagon wheel (an especially nostalgic symbol of the past), white house, the white birch, and the white church creates its own image of purity.

In New England, the historical transformation of temple to church has come back to its beginnings: the church is decorated with temple columns. I could not help seeing in this a hidden merging of bank and church, a symbol of the merit of making money without enjoying it.

37 & 38 *The misty blues of Maine.* My first glimpse of Maine came as such a surprise—a state so pure and unchanged, so proud of its heritage. Europeans always imagine America to be completely modern. It seemed remarkable to me that the English had found a place in America quite similar in climate and weather to the country from which they came. The name "New England" is well justified. The Spaniards, by contrast, settled in the South, where much of the land and the climate is like their own. I was so taken with the wet, misty beauty of the Maine coast that it became my vacation home for many years.

39 & 40 *Sailing the high seas.* Disney's world is based on dreams and fantasies. It gives children, and adults too, the feeling of how it must have been when a little boy, inspired by the authenticity of a ship's replica, dreamed of adventures on the seven seas. In the first picture the shadow of a grownup reflected on the water suggests that we are all affected by sailing ships, regardless of our age.

41 & 42 *An American creed.* On one of my many trips around the country, in constant search of what it is to be an American, I found this quotation planted at the entrance to a farm. The owner must have taken seriously what Dean Alfange, a sophisticated liberal and Democratic candidate for Governor of New York in the 1940s, wrote. It seems strikingly contrary to the general direction of our time and to the idea of a

welfare state. The picture on the right-hand page is the silhouette of a statue in San Francisco. The fluttering birds seem to make it truly alive.

43 & 44 *Jack London's world.* As a young man, I feverishly read Jack London and Zane Grey, wondering what it would be like to follow in their footsteps. In the years that followed, my imaginings came true. One of my first assignments in America in the 1950s was a story for *Holiday* about the San Francisco Bay area. The city immediately brought back memories of Jack London's books. As if driven by a magnetic force, I photographed the freights he rode and the last of the old ferries that had disappeared from the Bay after the bridge was built. *Holiday* was disappointed in my take. They had wanted pictures of modern housing and the beauty of the city. I came back with pictures of dogs, workers, bums, and glimpses of the life Jack London knew.

45 & 46 *The great railroad.* The railway symbolizes the great days of America's expansion—the nineteenth-century push to the west, the selling of pioneer territory, and the burgeoning of industries. It was a time of opportunity and general prosperity. The glamour of the iron-horse era has gone, but the nostalgia remains. I took the photograph on the left-hand page with a wide-angle lens to emphasize the power in the wheels by means of distortion.

47 & 48 *Communication.* The telegraph pole is the tree of the desert, a typical roadside sight between Los Angeles and Las Vegas. The highways leading up to and disappearing at the point of the horizon underline the immense vastness of the desert.

49 *The lonely prairie ranch.* Many ranches such as this, which one encounters by chance in the West, are still owned by the same families that staked claim to thousands of acres of land generations ago. The spirit of hard work and accomplishment which the first to arrive believed in still persists today, although the

circumstances and difficulties encountered are different. This picture was taken in Montana just before a summer rainstorm in 1972.

50 & 51 *The "heartland."* Flying over the wheat and corn belts of America's "heartland" makes one aware of the immensity and richness of this country's agriculture.

52 & 53 *From mediocrity to affluence.* A house and a car symbolize the well-being of the average American family. The picture on the left shows a typical street in the outlying regions of a big city, the one on the right a step closer to affluence: houses with cars, boats, and swimming pools.

54 *The regatta.* The scene is outside Seattle, Washington, with Mount Rainier in the background. I took this picture with a telephoto lens, not with a wide-angle lens as is sometimes supposed. The latter would have distorted the images at the far edges.

55 & 56 *From the depths of the canyon – Black and white.* When I was going down the Colorado River in a dory, I spotted this airplane flying from west to east. I was looking up between the steep canyon walls. The landscape, opposite, was photographed near Seattle in the spring. The incredible chiaroscuro of the dazzling white snow against the very black lava on this old volcano startled me.

57 & 58 *The separation.* Two photographs taken in the South in the 1960s. I was quite taken aback by the blatant atmosphere of segregation and the deep-rooted mistrust of one individual for another. Much has changed for the better.

59 & 60 *The way it was.* A nostalgic reminder of the past: an aristocracy and a way of life that flourished in the South before the Civil War. The picture on the right is of the Oak Alley Plantation, near Vacherie, Louisiana.

137

61 & 62 *Distant splendor.* One could still smell the splendor and elegance of the old South, a fragrance unfortunately slowly disappearing. On the other hand, decay can so often make a picturesque statement of its own.

63 & 64 *Who has the floor?* It might once have been said that the whites were the column of society and the blacks were allowed to sit on the steps. Times have changed. Now we all sit on the ground together. The picture on the left was taken in the South; the one on the right in the North.

65 & 66 *A freedom of choice.* Since the beginning of recorded history man has expressed himself on walls. There seems to be a certain inclination in the youth of today to go back to the cave man, to be wild again, to be naked and free. Was early man really like this? The desire is for freedom from convention, the use of materials without glorifying them, a house to sleep in, a car to take one from here to there, and a length of hair to express all these thoughts in a visual jest.

67 *Ballet magic.* For many years, I have had a lasting love affair with George Balanchine's New York City Ballet. I was first assigned to photograph the company by *Vogue* in 1950, and since then I haven't stopped photographing and admiring their very American spirit. This picture was taken during a rehearsal, a time when Balanchine does not want to give an idea of his very exact choreography, but conveys an impression of his indefatigable effort to improve on it. The triple-image photograph contributes to the feeling of movement.

68 & 69 *Rhythm.* For me, Louis Armstrong epitomizes American jazz. The photograph of him on the left was taken during an actual performance. The picture on the right might look like a parade, but it's a lively band at a football game.

70 & 71 *Television sports.* Football games and television are very much connected nowadays. Like baseball, the game is played for television because of the vast audience. When traveling, I stay in hotels and motels, often watching television, as reception is usually excellent. I turn off the sound and silently gaze at the abstract color spectacles, such as these.

72 & 73 *Football motions.* I am fascinated by the vibrant atmosphere and the staccato color—all so very American—of football games. I can watch the movement for hours, cheering enthusiastically for either side, not caring who wins. In the 1950s *Sports Illustrated* sent me to photograph football games, and these photographs are a result of that assignment. The editors were interested to see how I, as a European, would react to a game with which I was relatively unfamiliar. I took these pictures by exposing the film for one-tenth of a second, simultaneously moving the camera from right to left.

74, 75, 76 & 77 *The rodeo.* No other country has pursued the rodeo as a sport in the way America has. It is a work skill which has developed into a sport skill—a way of keeping alive something that is daring and courageous. In the time of the automobile and the airplane, the horse and rider still represent a manly tradition of the West. For the photographer the rodeo is very exciting: there are always unforeseen action and lots of surprises. The first three photographs were taken with a tenth-of-a-second exposure, photograph number 74 was taken at Madison Square Garden, number 75 from the judge's stand at a rodeo in California, number 76 during one in New Mexico. The fourth picture was taken in New Mexico during the shooting of an advertising assignment.

78 & 79 *An Indian powwow.* During a powwow of all the American Indian tribes in Seattle: a typical contemporary Indian meeting—with traditional teepees and modern vehicles. The powwows are not staged for

the tourists, though they are welcomed as spectators and are allowed to participate at the social dance. Dressing up, dancing, drumming, chanting, and singing are integral parts of Indian spiritual and cultural life. The event usually takes place on Indian grounds and lasts for several days, with festivities day and night. Even though contemporary objects invade the scene, tradition predominates.

80 & 81 *The Mardi Gras.* Perhaps we are really free only when we carry the mask of someone we would like to be. These pictures were taken during the Mardi Gras in New Orleans. The immense Uncle Sam had to be towed by a tractor.

82, 83 & 84 *In Disneyland.* Here one meets all the characters one knows so well from the screen, but in an added dimension. Mickey Mouse is a unique citizen of the United States; I was amazed to learn that he was

born on a drawing board during a train ride from Los Angeles to New York. How difficult it would be to cast his horoscope!

85 & 86 *Woman's evolution.* The eternal American blond goddess, riding in a convertible, showing off some of her assets, is no longer a frequent scene in Hollywood. Values have changed, and will keep changing—although not always for the better. The photograph on the right was taken during a 1971 Women's Liberation parade, the photo on the left, the evening of a movie premiere.

87 *The power of a woman.* In a way this photograph symbolizes for me the American man, who is quite unconscious of who has a hold on whom. The more beautiful the woman, the more powerful her thumb. It was not posed—none of my pictures ever are. The man just happened to be above the giant billboard

and waved to me as he saw me with camera in hand.

88 & 89 *The past in the present.* In the Southwest, many aspects of days gone by live on in the present. The nomadic spirit of certain Americans will never cease to exist, even though the road from covered wagon to trailer vehicles has been a long one.

90 & 91 *Simple things.* Some of the subtleties that distinguish Americans from other people are fascinating: a certain way of standing, worn-out sneakers, jukeboxes, coke bottles with straws. Both these pictures were taken using existing light in a small town coffee shop on the Fourth of July.

92 & 93 *Eye pollution.* A billboard advertising ice cream, one of millions of examples of eye pollution to be found throughout the country. On the right, the backdrop of dark clouds rendered the street illumination

an even more forceful reminder of the clutter of our civilization.

94 & 95 *Related compositions.* Reflections constantly appear as one walks through the cities, images creating the spirit of a city within a city, within yet another city. Only as a photographer can one preserve this perfection of overlaying images in compositions that hold together of themselves. Even when I am not photographing I stop and look, overtaken by the multitude of intercolliding images. I took the picture on the right while looking into the revolving door of a bank.

Street posters (left) juxtapose their many layers in obscure meanings and rich abstract combinations. These and other patterns, such as those made by a can squashed by thousands of cars, or painted traffic lines eroded by wear and weather, always catch my eye. Photographing this otherwise meaningless debris, one finds similarities of composition. It is also interest-

ing to observe how one often discovers the same key to different compositions, like the opposing ones on these two pages.

96 & 97 *New York reflections*. These two pictures show reflections in shop windows along Fifth Avenue. The one on the right was taken while the General Motors building was being constructed, and the one on the left was photographed in 1971.

98 & 99 *Politics and business unite*. America made it possible for the United Nations to have a permanent home in New York, a city of all nationalities, united or not. This picture was taken in the General Assembly building, where diplomats are to be seen casually riding up and down on the escalator as symbols of American industry and high finance reflect on them.

All American cities are under constant construction. Buildings are torn down and new ones erected with

such speed that the faces of streets seem to change overnight.

100 & 101 *From rags to riches*. The myth of the news-paper boy becoming a millionaire still persists. In him there is a certain fascination of child, youth, a young man responsible for a job. There is a pride which has nothing to do with earnings but with being counted as a responsible member of a functioning news-hungry society.

We all look into them—the big black limousines. Who owns them? The limousines park in front of beautiful houses, hotels, shops, office buildings, each guarded by a chauffeur who seems to be a human extension of the car. There is a certain aura of mystery and privacy surrounding these limousines; the owners wear them as did knights their armor in days gone by.

102 *Congestion*. Ever since my first encounter with

New York, my fascination with the city which has been my home for more than twenty years has persisted. Whenever I am free, I wander around New York, trying to catch moments of its extreme dynamism. This picture was taken with a telephoto lens. The scene of this photograph is Lexington Avenue after a rare March snowstorm at five o'clock in the evening.

103 & 104 *New York: at night and from above.* There is nothing more exciting than approaching New York City by air. As a photographer my comings and goings are frequent. There is no city which one loves more to leave and come back to than New York. The taxi ride from Kennedy Airport to Manhattan gives one a certain electric feeling that the ride into no other city does.

The impressionistic study of an American city from the top of a skyscraper at night (right) was created by making four separate exposures on the same frame of film, each from a different angle, and by moving the camera up and down.

105 *Love.* I end my letters with "Love," and it seems appropriate that my last picture should express my feeling for this great country with "Love" written across its skies.

General Notes

Neither my equipment nor techniques have changed much since I wrote about them in *The Creation*. But, for those who may not have a copy of that book, the following may be of some interest to camera owners.

I have always used Kodachrome, and as testimony to its quality, I must say that even the photographs I took with the old film, Kodachrome I, have retained their color intensity through the years.

Since Kodachrome 25 came on the market, I have used it constantly. Because it has fine definition and almost no grain, I have never seen any reason to try out other materials. I don't mean this to sound like a plug for the film; I have never worked for Kodak—only *with* Kodak, and in so many different situations that by now I know the film's characteristics by heart.

I am often asked if I use a tripod. I almost never do. I have to carry cameras, and because I like to travel light, I keep my equipment to a minimum. I have always worked with Leica M3 and M4 cameras and occasionally with Pentax cameras with Leica lenses attached. From 1969 to the present time I also have taken pictures with the Leicaflex camera and lenses, which I find eminently satisfactory.

A final word about lenses and filters. I work mostly with lenses of 21, 28, 50, 90, 180, and 400 mm. The Micro-Nikkor 55-mm lens I find extremely useful for close-ups. I seldom use a filter, except for a polarizing filter, which I find essential when I wish to reduce reflections and glare. I use it also when taking photographs through the window of a plane or an automobile, which, for one thing, is never completely clean, and, for another, will usually pick up unwanted reflections from behind.

It is not my purpose to make this a technical treatise, and I assume that readers interested in learning what lenses to use for what occasions and, in general, how to handle a camera, color film, exposure meters, and other equipment, will turn to the many excellent technical books on the market or to the literature that the various manufacturers supply.

If I have any word of advice to give, it is that a photographer should learn to work with the minimum amount of equipment. The more you are able to forget your equipment, the more time you have to concentrate on the subject and on the composition. The camera should become an extension of your eye, nothing else.